Exploring New World Imagery

Spanish Colonial Papers

from the

2002 Mayer Center Symposium

Edited by Donna Pierce

A publication of the Frederick and Jan Mayer Center
for Pre-Columbian and Spanish Colonial Art
at the Denver Art Museum

Frederick + Jan
MAYER
CENTER
Pre-Columbian +
Spanish Colonial
A R T

DENVER ART MUSEUM
2005

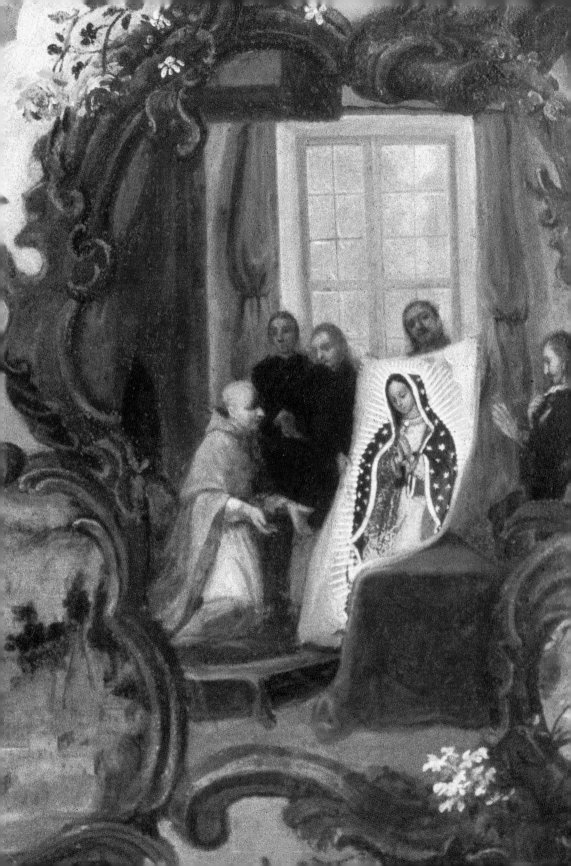

To Frederick and Jan Mayer
with affection and gratitude for their
vision, passion, and generosity.

Printed and bound by Johnson Printing, Boulder, Colorado
Distributed by the University of Texas Press

ISBN 0-914738-51-8
Library of Congress Control Number 2005925637

Editor: Donna Pierce
Copyeditor: Nancy Mann
Designer: Julie Wilson

Translations: Margarita González Arredondo, Tariana Navas-Nieves,
Clara de la Fuentes Ricciardi, and Anne Tennant

Cover illustration: Cristóbal de Villalpando, *Joseph Claims Benjamin as his Slave*
(detail), 1700-1714 (page 122).
Frontispiece: Nicolás Enríquez, *Virgin of Guadalupe* (detail), c. 1740 (page 60).

CONTRIBUTORS
Carolyn Dean *University of California, Santa Cruz*
Samuel Y. Edgerton *Williams College, Williamstown, Massachusetts*
Juana Gutiérrez Haces *Universidad Nacional Autónoma de México, Mexico City*
Alexandra Kennedy-Troya *Universidad de Cuenca, Ecuador*
Jeanette Favrot Peterson *University of California, Santa Barbara*

CONTENTS

FOREWORD

The Denver Art Museum counts among its greatest resources a Spanish colonial collection rich in art from all over Latin America. This collection began in 1936 with Anne Evans's gift of *santos* from Colorado and New Mexico. In 1952 Director Otto Bach made the first purchase of Pre-Columbian art, and in 1968 he established a New World Department that brought Pre-Columbian and Spanish Colonial objects together under the spirited curatorship of Robert Stroessner. The department flourished especially through the interest and support of longtime museum trustee Frederick Mayer and his wife Jan. Spanish Colonial donations of note include the Frank Barrows Freyer Memorial Collection of art from Peru; the Stapleton Foundation's collection of Colombian and Ecuadorian colonial art, a donation made possible by the Renchard family; and Spanish colonial silver from the Robert Appleman family. Major gifts from the Mayers included important examples of Mexican colonial painting as well as their peerless collection of Pre-Columbian art from Costa Rica.

In 1999 Donna Pierce and Margaret Young-Sánchez came to the museum as the Frederick and Jan Mayer Curators of Spanish Colonial Art and Pre-Columbian Art, respectively. The continued growth of the New World Department has been ensured by a gift from the Mayers that underwrites two curatorial positions as well as the department's administrative costs and programming: the Frederick and Jan Mayer Center for Pre-Columbian and Spanish Colonial Art sponsors scholarly activities including annual symposia, fellowships, study trips, and publications such as this volume.

Over the years, the Mayers have supported the museum's larger mission at every turn. We thank them for their enlightened generosity and for their dedication to the museum as a whole and to the study of New World art in particular.

Lewis I. Sharp
Director
Denver Art Museum

ACKNOWLEDGMENTS

The Frederick and Jan Mayer Center for Pre-Columbian and Spanish Colonial Art at the Denver Art Museum sponsors annual symposia in these two fields of art. Usually alternating between Pre-Columbian and Spanish Colonial topics, we hosted in 2002 a joint session on both topics with an emphasis on objects in the collections at the museum. With additional funding from the Cooke Daniels Memorial Lecture Fund, Margaret Young-Sánchez, Curator of Pre-Columbian Art, and I invited scholars in our respective fields to make alternating presentations at the New World Art Symposium in March of that year. The resulting exchange of ideas provided a lively and edifying two-day experience.

The Mayer Center also sponsors the publication of proceedings of the symposia. This issue includes the Spanish Colonial papers of the 2002 session; the Pre-Columbian papers will be published in a separate volume. The Pre-Columbian symposium presentations included Warwick Bray of the University of London on Panamanian goldwork; Carol Mackey, California State University and Joanne Pillsbury, University of East Anglia, England, in a joint paper on Chimú silverwork; Patricia Sarro, Youngstown State University, on Teotihuacan stone sculpture; Marc Zender, University of Calgary, on Maya inscriptions; Rebecca Stone-Miller, Emory University, on shamanism in Costa Rican art; and Margaret Young-Sánchez, Denver Art Museum, on Tiwanaku art.

Spanish Colonial scholars making presentations included Samuel Y. Edgerton, Professor of Art History at Williams College, whose lecture for the symposium addressed several iconographic topics in sixteenth-century mission art and architecture of Mexico. His paper on these broad concepts has been focused more specifically for this publication and now bears the title "Christian Cross as Indigenous 'World Tree' in Sixteenth-Century Mexico: The 'Atrio' Cross in the Frederick and Jan Mayer Collection." In it, the Mayer cross is published for the first time.

The second paper in this volume is by Jeanette Favrot Peterson, Associate Professor of Art History at the University of California, Santa Barbara, who spoke on the Virgin of Guadalupe. Her article here,

"The Reproducibility of the Sacred: Simulacra of the Virgin of Guadalupe," includes an analysis of the recently discovered 1656 painting by José Juárez with the earliest known apparition scenes.

Carolyn Dean, Professor of Art History at the University of California at Santa Cruz, addressed the topic of Inka portraiture in viceregal Peru in her symposium presentation entitled "Inka Nobles, Portraiture and Paradox in Colonial Peru." In her paper of the same title here, she publishes the first detailed scholarly analysis of the Denver Art Museum's portrait of an Inka princess and its series of Inka kings.

Juana Gutiérrez Haces, Research Fellow and Art History Professor at the Instituto de Investigaciones Estéticas of the Universidad Nacional Autónoma de México, presented an overview of her new research on "The Mexican Painter Cristóbal de Villalpando: His Life and Legacy." Her paper of the same title here includes numerous illustrations of spectacular works by this artist, as well as the recently discovered image *Joseph Claims Benjamin as His Slave* from the series on the life of Joseph of the Old Testament, now in the collection of Frederick and Jan Mayer at the Denver Art Museum.

At the symposium, Alexandra Kennedy-Troya, Professor of Art History at the Universidad de Cuenca in Ecuador, presented a general paper on the colonial sculpture of Ecuador. Her topic here has evolved into a discussion of a significant Ecuadorian painter, "Miguel de Santiago (c. 1633-1706): The Creation and Recreation of the Quito School." It includes an analysis of his import to later artists and to the nineteenth-century movement toward a national Ecuadorian artistic identity, bringing our volume into modern times.

Also during the 2002 symposium, Cristina Esteras Martín, Professor of Art History at the Universidad Complutense de Madrid in Spain, gave an overview on silver and gold work in colonial Latin America. Her presentation was based in part on her essay "La platería hispanoamericana, arte y tradición cultural," published in *Historia del arte iberoamericana,* edited by Ramon Gutiérrez and Rodrigo Gutiérrez Viñuales (Barcelona and Madrid: Lunwerg Editores, 2000), 118-40. We had hoped to publish the

updated version in English in this volume but were unable to secure permission to do so.

María Concepción García Saíz, Chief Curator, Department of Colonial Art at the Museo de América in Madrid, made a presentation on the *casta* (caste) paintings depicting families of mixed race in Mexico and Peru. Her presentation was based in part on her essay "The Artistic Development of 'Casta' Painting" in the exhibition catalog *New World Orders: Casta Painting and Colonial Latin America,* edited by Ilona Katzew (New York: Americas Society, 1996) and is not included in this volume.

We are grateful to these scholars for their participation in the symposium and their contributions to this publication. We also thank them for their patience through the long process of translation, image gathering, and editing. We look forward to their ongoing participation in future Mayer Center symposia as both presenters and attendees.

I would also like to acknowledge the staff of the New World Department at the Denver Art Museum who worked hard to organize the symposium, particularly Curatorial Assistants Julie Wilson and Christine Deal as well as my counterpart, Dr. Margaret Young-Sánchez, Frederick and Jan Mayer Curator of Pre-Columbian Art. Denver Art Museum Events Staff headed by Mary K. Dillon, Audio-Visual Staff under Elizabeth Gilmore, and Security Staff led by Tony Fortunato provided significant and cheerful support. The unflagging support of Lewis Sharp, Director, and Timothy Standring, Chief Curator, is constant and appreciated by all of us.

In the preparation of this publication, I am grateful to DAM staff Clara de la Fuente Ricciardi, Tariana Navas-Nieves, and Anne Tennant for translation assistance and to Lucy Clark for all-around support. We thank Nancy Mann of the University of Colorado for her editing skills and patience. Thanks are due to the staff of Johnson Printing in Boulder, Colorado, for their unfailing professionalism, particularly Greg Walz. My profound gratitude goes to Julie Wilson, now Mayer Center Program Coordinator/Junior Scholar, for coordination, image gathering, and, most importantly, the elegant and clean design of this volume.

On behalf of all of us, I want to express our deepest gratitude to Frederick and Jan Mayer for providing the opportunity to bring together

such a distinguished group of scholars from many parts of the world to share ideas, as well as for the funding to publish the results in this volume. Not only do they make it possible, they fully participate in the symposia themselves and assist us every step of the way. We are truly blessed.

Donna Pierce
Frederick and Jan Mayer Curator of Spanish Colonial Art
New World Department
Denver Art Museum

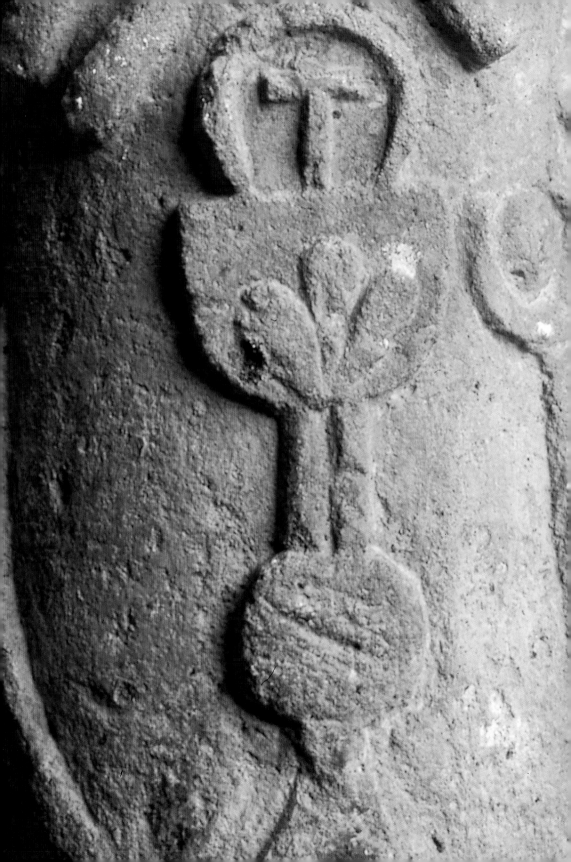

Figures

Christian Cross as Indigenous "World Tree" in Sixteenth-Century Mexico:
The "Atrio" Cross in the Frederick and Jan Mayer Collection

Samuel Y. Edgerton
Professor of Art History, Williams College
Williamstown, Massachusetts

> Here, by the Chapel of San José, patron saint of this New Spain, there was in the spacious patio, a cross, higher than the highest tower in the City [of Mexico], visible to passers-by in all the neighboring streets....

So begins a quaint anecdote by Fray Juan de Torquemada, author of *Monarquía Indiana*, a multivolume chronicle of the Spanish "spiritual conquest" of Aztec Mexico, published in Seville, 1615.[1] The Franciscan friar-missionary liked to digress occasionally about religious architecture, mostly Christian of course, but often in admiration of how the ancients, including the preconquest American Indians, built their "temples" in forms appropriate to the symbols of their traditional pagan rituals. His mention of the San José cross is therefore significant, because he seemed to recognize that the indigenous people of Mexico had their own reasons for venerating this particular symbol. He goes on with the story:

> [The cross] was made from a very tall cypress tree that grew in the forest of Chapultepec almost a league west of this city. The elder Mexicans regarded this tree as a deified thing, and so they cleaned and debarked it with more than usual care, in keeping with its preciousness. The religious [friars and their Indian converts] cut the tree and prepared to raise it up in the center of the patio. But it happened that in spite of the large number of Mexicans who were there (including many *principales*), they were unable to lift the cross off the ground. At that moment, there was an elderly holy man at prayer in the chapel choir, who saw in a revelation that the demon was holding the cross down and afflicting its movement. The old man rushed out into the patio, pushed the people aside, and shouted, "How can you raise this cross when it is being prevented by the demon?" And then running around to the head

13

of the cross, shouted again, "Get away you evil one, they are rais-
ing the cross of Jesus Christ! The banner of our faith shall be
lofted!" Suddenly, in plain view, everyone saw the demon run away,
and, after that, they easily raised the huge tree. (My translation
after Torquemada 1975, 1:414–415)

Torquemada's charming tale actually recounts the founding of the
unique Mexican missionary *convento,* as it is commonly called in Spanish, a
European-style monastic establishment ingeniously modified in the New
World to christianize heathen Indians. It consisted of a friary, a church,
and a special walled courtyard, sometimes referred to as the *atrio,* but more
often termed the patio by the contemporaneous friars, to which was joined
the church as well as a separate open-ended chapel (fig. 1). The open
chapel of San José de los Naturales mentioned by Torquemada (and named
for Saint Joseph, chosen patron of the indigenous natives of Mexico) was
first constructed in the early 1530s (McAndrew 1965, 368). Although
razed long ago, San José did establish the idea for the many similar open
chapels that followed (and many are still extant), all facing onto expansive
patios where Indians would gather to hear mass delivered directly from an
outdoor altar. A monumental cross, henceforth carved most often in stone,
of some eight to ten feet in height (in-
cluding pedestal, but never again so tall
as that at San José[2]), was likewise usu-
ally posted in the center of the typical
convento patio (McAndrew 1965, 247–
254; Galván González 1978, 35–49;
Fernández 1992, 191–198; Edgerton
2001, 65–71).[3] In this combination,
the whole complex served as a func-
tional, even theatrical teaching arena,
and was replicated in hundreds of like
conventos built all over Mexico by all the
missionary orders during the sixteenth
century: Franciscans, Dominicans,
Augustinians, and lastly the late arriv-

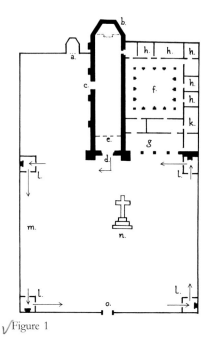

Figure 1

14

ing Jesuits (Edgerton 2001, 35–73). The ubiquitous patio was also laid out so that Indian catechumens could march around its internal perimeter in religious procession, halting at small shrines called *posas* erected in each corner, where they would hear a lesson or even perform a miracle play. Most importantly, however—whether coincidentally, or whether the friars planned this intentionally or even in cahoots with their native converts—the patio with its central cross was so oriented that the Indians might perceive it as signifying their traditional universe, conceived symbolically as a cosmic quincunx squared to the cardinal directions and with a great tree centered in its navel (McAndrew 1965, 237–240; Edgerton 2001, 35–71). To the Indians, this primordial tree, rooted in the *umbilicus mundi,* with branches reaching skyward, was the divine conduit by which supernatural sustenance passed between heaven and earth. The remarkable similarity of the Christian patio cross, in both physical form and spiritual content, to the native "world tree" concept certainly helped to ease the Indians' coerced conversion, even if the neophyte catechumens were only subconsciously aware of it.

The notion of the "world tree" appears in the arts and legends of nearly all the indigenous cultures of preconquest Mesoamerica, and is frequently depicted in native style in their beautifully illuminated screen-fold codices, such as the Maya Codex Dresden (fig. 2), the Mixtec Codex Vindobonensis (fig. 3), and the Nahua Codex Borgia (fig. 4, which actually shows cobs of maize sprouting from its limbs!).[4] While many of these books were called "works of the devil" and destroyed by fanatical missionaries, the few codices that have survived were saved and sometimes even annotated by the friars themselves. Thus, it's certain the Christians too were aware that the supposedly pagan world tree strikingly resembled the sacred symbol

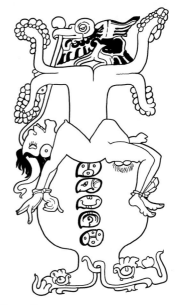

Figure 2

15

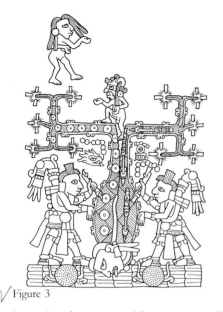

Figure 3

of Jesus' cross. In fact, this apparent similarity may have reinforced the belief held by many Christians during the half-millennial 1500s that the "Indies, the furthest end of Asia," were contiguous with newly discovered America, as Columbus and all the early explorers thought, and had once been converted to Christianity by no less than Saint Thomas the Apostle. In the meantime, the devil had perverted the apostle's work, and the Indians had returned to pagan worship (Lafaye 1976). Nevertheless, the demon could not erase all traces of original Christianity like the symbol of the cross, although he managed to corrupt it by demanding that the world tree be sustained by human sacrifice (note that the Maya and Aztec world trees depicted in figs. 2 and 4 are both shown being nourished by human blood, and the Mixtec one, fig. 3, grows from a severed human head). While the friars no doubt worried about this old sanguine association as they raised their "banner of the Faith" anew, they did manage, with Indian cooperation, to both co-opt the world tree and successfully reassimilate it with the triumphant Christian cross.

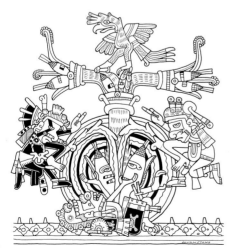

Figure 4

As a matter of fact, most stone crosses created for *convento* patios during the sixteenth and seventeenth centuries were sculpted by indigenous artisans skilled in both traditional native and current European masonry techniques. Since the first missionaries in Mexico were so few in number, they had to depend on Indian craftspersons

16

for the building and decoration of their new *conventos*. Several schools for training natives in the European styles were, then, established in the various jurisdictions of the religious orders, the most renowned of which was that at San José de los Naturales, the very place where that first famous patio cross so conspicuously towered over Mexico City.

The Indians, of course, were already adept in the art of sculpture, as their many surviving preconquest masterpieces attest. Moreover, the visual arts were traditionally practiced by talented native aristocrats, *principales* as the Spanish called them, and we may conjecture that such highborn artists contributed more than just their handicraft to the peculiar typological conception of the Mexican patio cross—peculiar, because the most obvious feature of patio crosses, as distinguished from other representations of the Crucifixion placed elsewhere in the church and *convento* complex, is that the body of Christ is almost never shown suspended upon them.[5]

On the other hand, the horizontal and vertical arms of the patio crosses were quite frequently covered with a plethora of Christological symbols carved in relief, some traditionally European but others unique to Mexico. Jesus' sacrifice, even without the presence of his hanging body, was signified graphically by stylized swatches of blood, represented in the Indian manner of clustered droplets streaming from drilled holes where the Savior's hands and feet would have been nailed, as illustrated in the splendid cross fixed to the church façade rather than in the patio center of the Franciscan *convento* at Tepeapulco, Hidalgo

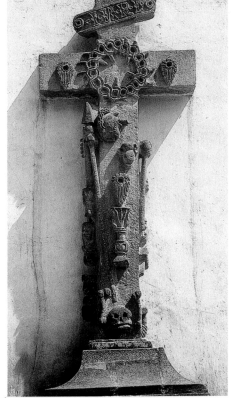

Figure 5

17

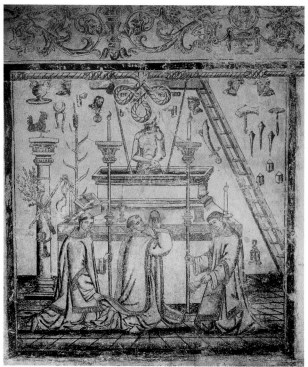

Figure 6

state (fig. 5). Also common to these crosses was a sculpted human skull, sometimes with bones and even crossbones, positioned at the base. While the skull symbol was quite traditional in European depictions of the Crucifixion (which took place, according to scripture, on Golgotha, the "Place of the Skull," typologically above the grave of Adam), it also bore striking resemblance to the imagery of the indigenous world tree, as has already been illustrated.

Especially characteristic to most of these Mexican crosses was their display in raised relief, almost in *horror vacui* arrangement, of the "Instruments of Jesus' Passion." To be sure, such images as stimuli for Christian devotion were commonplace in European painting, sculpture, and especially prints (Berliner 1955; Schiller 1974, 2:84–272; Lara 1996; Parshall 1999), but they were never to my knowledge represented directly on the post and arms of a large freestanding stone cross. From the Middle Ages through the Renaissance, and ever more so during the Reformation and Counter Reformation, the *Arma Christi*, as they were called in the

18

Latin liturgy, became a popular subject for *Andachtsbilder*, as German art historians named this special genre, intended to arouse intense religious emotion in the beholder. The instruments of the Passion, for example, should be contemplated one at a time, so that the viewer might literally feel the pain that each inflicted on Jesus (Suckak 1977). The instruments were often represented in association with a miracle taken quite seriously at the time known as the "Mass of St. Gregory." The story (in several variations) recounted how sixth-century Pope Gregory the Great, having discovered that a trusted acolyte denied the mystery of transubstantiation, attended mass to pray for guidance. To his astonishment he suddenly saw Jesus rising from the altar, surrounded by the instruments of his torture, and bleeding profusely into the chalice. An elegant mural of this apparition is still to be seen in the Franciscan *convento* at Tepeapulco (fig. 6), and prints of the subject were no doubt in circulation throughout Mexico, providing a ready source of Passion iconography for sculptors of the patio crosses.[6]

As carved, however, the images of these instruments are generally stylized, looking sometimes more like hieroglyphic logograms. Art historian Eloise Quiñones Keber (personal communication) has suggested that

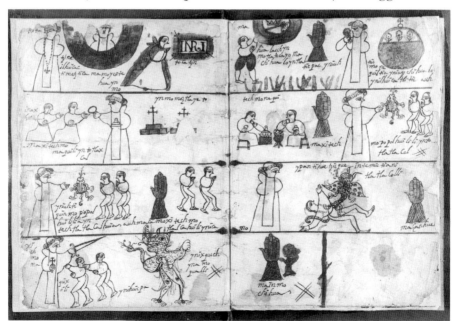

Figure 7

they might even have been so formed because the Indian artisans were thinking of them in terms of the pictographic language symbols of their indigenous codices. The missionary friars in fact admired the Indians' ability to "read" pictorial messages and even invented a pictographic system of their own known as "Testerian hieroglyphics" in order to better communicate Christian ideas to the natives, a system from which some of the patio cross symbols may also have been derived (see fig. 7, a delightful seventeenth-century rebus rendering of the "Lord's Prayer" in Testerian hieroglyphics). One may imagine that the friars, after leading their native neophytes in their daily lessons around the patios and studying the didactic messages of the painted Bible stories on the walls (Edgerton 2001, 116–119), would turn finally to the great stone cross in the center, where the catechumens should contemplate individually the sculpted instruments, just as if they were following glyph by glyph the story of Jesus' Passion in a native-style codex.

The juncture of horizontal arms and vertical post of the patio cross is, from the artistic viewpoint, the prime location for placing a particularly poignant symbol. Hence, a crown of thorns motif was usually represented here, as surrogate signifier of the tormented head of Christ. Sometimes it too was much abstracted, becoming a simple wreath or even a flower or circular "mirror" inlaid in native obsidian, which symbols, however, no longer belonged to the canonical European instruments of Jesus' Passion. Nonetheless, these occasional substitutions at the juncture of the cross did have profound significance for indigenous viewers, and I shall return to discuss the flower symbol in particular later in the essay.[7] I would speak first, however, about another motif almost as common as the crown of thorns at the crossing of many, especially Augustinian, patio examples, namely the disembodied face of the Savior projected in relief, not so much on as embedded *in* the cross's fabric. The friars doubtless encouraged that this image be simply construed as a reference to Veronica's handkerchief, another sacred relic included among the canonical Passion instruments (Jesus' features were miraculously impressed upon it when Veronica wiped his brow). But I argue that Indian artists, certainly the two who carved

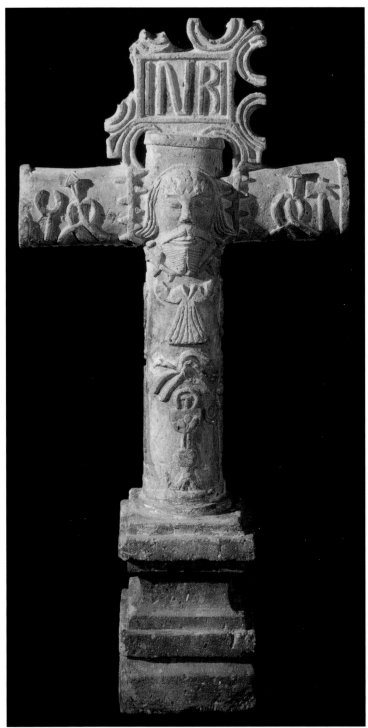

Figure 8

21

the examples next to be introduced, also understood it as confirming that Jesus and his cross were inseparably fused with the indigenous world tree.

A true masterpiece of this genre is to be found today in the renowned art collection of Frederick and Jan Mayer, Denver, Colorado (fig. 8). Unfortunately, neither the artist, certainly an ingenious Indian, nor the original venue is recorded. It was carved from gray volcanic stone and once stood on a raised pedestal, probably elevated to be seen just above the viewer's eye level. The cross itself is relatively small, only about four feet in height and slightly less than two feet across the arms. Similar small crosses are still to be seen on pedestals in several Augustinian *conventos* in the Mexican state of Hidalgo, the geographical region and religious order

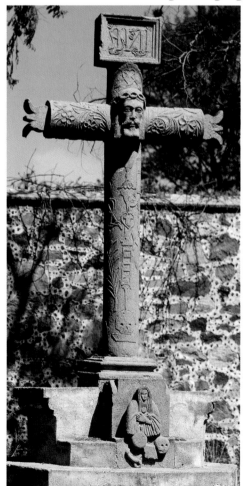

that I suspect provided the original location for the Mayer cross.[8] As will be demonstrated further on, this fine work of art was created no earlier than 1590 and probably some time well after 1600.

In form if not size, the Mayer cross is very similar to another, eight-foot-tall patio cross still more or less *in situ* beside the Augustinian *convento* at Acolman, not far from Mexico City and close to the famous ancient pyramids of Teotihuacan (fig. 9). It was sculpted by a different native artisan, in my opinion less talented than the master of the Mayer cross. Nevertheless, both share several iconographic similarities, particularly the image of Jesus' face in high relief centered in the cross arms.

Figure 9

22

Both are also decorated in low relief with an array of glyph-like symbols depicting the instruments of the Savior's Passion, carved on all sides of the Mayer cross but only on the front of the Acolman example. Jesus' bearded face projecting from the center of the Acolman cross gives the added impression that the extended horizontal cross arms on either side are Jesus' own arms stylized as tree limbs. They are even shown entwined by leaves and flowers, and tipped at the ends with tri-lobed motifs that look like outstretched fingers. Even the conventional "INRI" placard (initials for *Iesus Nazarini Rex Iudorum*, "Jesus of Nazareth King of the Jews") that Pontius Pilate ordered hung up on the cross to humiliate Jesus, almost always shown appended to its top, is represented here with the four letters overlapping a spray of leaves.

To be sure, theologians in the Old World had, almost since the dawn of Christianity, preached that the "Cross of Redemption" bore typological connection to sacred trees, especially the Old Testament Tree of Knowledge in the Garden of Eden where Adam and Eve committed the original sin. Scriptural commentators made frequent reference to the "Cedars of Lebanon" mentioned in the Book of Psalms (104:16) as the "trees of the Lord," whose evergreen and rot-resistant qualities symbolized the Savior's promise of eternal life. In the New World, the exegetical terms used for these trees were often extended (in sermons in Nahuatl) to the tall indigenous cypress, the same coniferous species as that from which the giant patio cross of San José de los Naturales was cut (Burkhart 2001, 15–18). In any case, the Mexican patio cross offers a classic illustration of what I have called the "principle of expedient selection," the missionary friars' proselytizing strategy of emphasizing just those Christian doctrines and rituals that bore the closest similarity to preconquest native traditions (Edgerton 2001, 1–13).

Look closely at the images of the Passion instruments on all three of our illustrated crosses. While these symbols seem at first sight to be randomly spaced about the post and arms, I can demonstrate that some at least were positioned in deliberate relation to one another for particular narrative coherence—in terms not so much of orthodox Christian interpretation as of the native artists' own cultural perceptions of the Passion

story. Perhaps a useful analogy is to think of them as performing like icons on a modern computer screen; when the eye "clicks" on any one, a window opens in the imagination, revealing a specific moment in the narrative. The programmer may arrange the icons in any order, moving them around in different sequences, or even "retouching" them individually according to his/her own cultural or ideological predispositions.

On all three crosses the sacramental chalice is carved prominently on the front side below the central juncture. The chalice, of course, is the instrument in which Catholics believe wine becomes miraculously transubstantiated into Jesus' blood, and on the cross at Tepeapulco, blood spills directly from one of his wounds into the chalice just as it does in the "Mass of St. Gregory." One might think the missionary friars would have been bothered by such overt emphasis on blood effusion, reminding the Indians too much of their own preconquest practice of blood sacrifice. Moreover, on the Acolman cross the iconic cup is positioned exactly where the heart should be if Jesus' body is conflated with the world tree, suggesting again but more subtly, as a sixteenth-century Mexican Indian might still have noticed, that the Christian mystery did have its parallel in the now-condemned former ritual.

Along with the chalice (more on this icon later), native artists usually depicted several other important instruments on the prominent front of their crosses. On the Acolman cross, for instance, there are the column at which Jesus was flagellated, surmounted by the cock that crowed thrice signaling St. Peter's denial; the ladder by which Jesus' body was removed

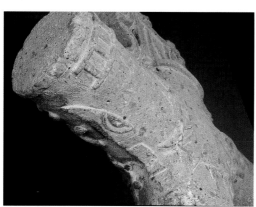

Figure 10

from the cross; the palm signifying his martyrdom; and the nail that pierced his feet.

Turning now to the richly carved Mayer cross, we note how this artist arranged his assortment of holy instruments as native-styled symbols with unusual originality. Remarkably, he took advantage of

every surface front and
back, whether angled or
curved, in order to display
the icons. Since the cross
was originally elevated on
a pedestal and thus meant
to be viewed from below,
the artist even exploited
the underside of its hori-
zontal arms. Under the

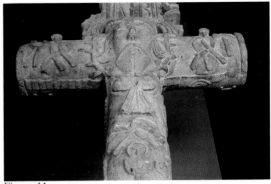

Figure 11

proper left arm and bending onto the post, for instance, he depicted a
knife still stuck to a slice of the ear that St. Peter hacked off the high
priest's servant on the night of Christ's arrest (fig. 10). On the right un-
derarm (fig. 11, to the left side of the photograph), he carved what ap-
pears to be a flattened staircase, no doubt intended to represent the *Scala
Sancta* or "Holy Stairs" up which Jesus was led by his captors to be pre-
sented before Pontius Pilate. The stairs were allegedly brought to Rome
by St. Helena, mother of the Emperor Constantine. In 1589, Pope Sixtus
V moved the sacred relic to a new shrine near the Basilica of St. John in
the Lateran, where for the first time they could
be publicly visited by pilgrims, who were of-
fered special indulgences for climbing the steps
on their knees.

The presence of this latter image, along
with the fact that the Mayer cross shows an
unusual form of the column at which Jesus
was scourged (on the lower proper right side
of the vertical post, fig. 12), gives us indica-
tion of its *terminus a quo* date. Instead of be-
ing figured as a full-sized classical pillar after
the traditional conception of the supposed
original in Jerusalem, the Mayer rendition
shows what looks like a simple post on a
flanged base with a distinct ring at the top from

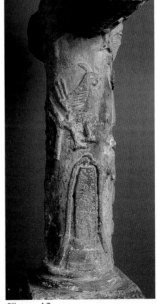

Figure 12

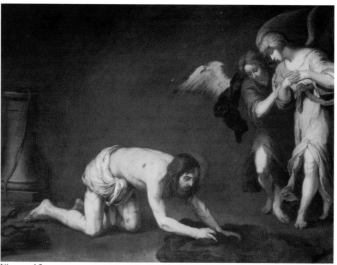

Figure 13

which ropes are dangling on either side. This conception surely derived
from the shape of another famous relic also in Rome in the ancient Church
of Santa Prassede, claimed by the latter to be the true original. It is actu-
ally only a four-foot-high truncated column, a stanchion really, too short
for Jesus to have been tied by ropes wrapped around it; rather, he would
have had to be tethered to it by ropes extending from a ring fixed in the
top. The Santa Prassede relic gained special authority during the Counter
Reformation (Mâle 1932, 263–267), especially after the Council of Trent
published its decrees in 1563 admonishing artists to be more "realistic" in
their depictions of holy stories (Wittkower 1958, 1).

Both the Santa Prassede column and the Lateran *Scala Sancta* were
major "tourist attractions" during the great Jubilee year of 1600, when
thousands of pious pilgrims from all over the Catholic world flocked to
Rome for this once-in-a-century opportunity to see and touch the holy
relics. Immediately and long after, many paintings, statues, and prints
appeared showing this shortened version rather than the traditional pillar.
One of the most poignant is a canvas, ca. 1668–1670, by Bartolomé
Esteban Murillo now in the Museum of Fine Arts, Boston (fig. 13), de-
picting the Santa Prassede whipping post at left, while a bruised and
bleeding Jesus crawls away on hands and knees as two angels despair at
his torment.[9]

As on the other two crosses, most of the Passion instruments carved on the Mayer cross seem to be in no particular order. Nevertheless, Jesus' garment is logically placed just under his embossed face (fig. 11), and St. Peter's cock icon to its right (fig. 12) is perched above the column, his conventional roost in most patio cross representations. However, the pot containing vinegar and gall just to the left of the robe (fig. 14) appears incongruously suspended above a spear. On the other hand, the pliers, spikes, ropes, and hammer carved on the front-side ends of the cross bar (fig. 8) and the ladder images neatly wrapped around the same ends behind (fig. 15) do indicate just how purposefully the artist linked the meaning of these icons to their locations on the cross in order to arouse sympathetic compassion for, even kinesthetic participation in, the Crucifixion tragedy. When the cross is seen from the front side, the viewer should sense the Savior's painful suffering while contemplating the cruel tools that nailed his hands. Walking around to the back, the viewer sees only the ladders "leaning" against the cross arm, which thus conjure up the melancholy scene of Nicodemus and Joseph of Arimathea climbing up these rickety rungs as they struggled to take down Jesus' lifeless body.

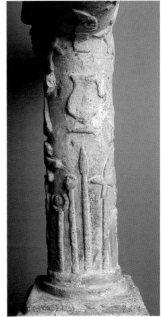

Figure 14

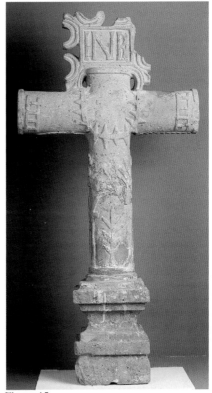

Figure 15

Between the ladders, on the broad back of the cross behind Jesus' face (fig. 15), the artist depicted no other instruments save the Crown of Thorns looping around his "shoulders" like a spine-studded necklace rather than as a diadem set conventionally on his brow as in the more innocuous rendition on the Acolman cross. Again, this solitary icon was intended to signify, and kinesthetically stimulate in the viewer, the same pain that Jesus suffered; hence the artist chose to emphasize the spiky barbs by literally pressing them into Jesus' sensitive world-tree "flesh."

Looking next at the bottom proper left side of the post of the Mayer cross (fig. 14), we observe that the artist carved an assortment of tall thin shafts that appear to represent, from left to right, a long rod holding the sponge soaked in vinegar and gall that the Gospel says was tauntingly offered to the suffering Christ, the "hyssop," the spear that pierced his side, and a halberd. "Hyssop," as mentioned in the same scriptural account (John 19:29), was apparently a sort of reedy wood the ancient Hebrews associated with blood sacrifice, which was likewise thrust at Jesus on the cross.[10] In any case, with almost cinematic effect our clever artist depicted these instruments side-by-side and vertical, intruding suddenly into the cross's space. Indeed, they seem to be cropped from an

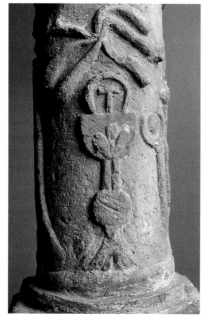

"off-screen" group of jeering soldiers and spectators jabbing at the Savior from ground level—and implying that we latter-day voyeurs inadvertently join, and thus become complicit with, Jesus' torturers.

At the very bottom of the front side of the Mayer cross, our sculptor placed his version of the chalice (fig. 16, just under the scourge). Three tiny flower-like petals decorate its bowl, from which the circular Host, embossed with a cross, arises. The stem of the chalice in turn rises from a rounded disk above a splayed gadrooned base.

Figure 16

28

While the carving of this chalice may look like a somewhat awkward rendition of the more stylish chalice on the Acolman cross, I submit, encouraged by the already examined inventiveness of this inspired artist, that he intended his chalice to look like a seedling plant: the gadrooned base is the divided root, the disk above it the seed cotyledon, and the cup above that a blooming calyx with the Host as extending stamen.

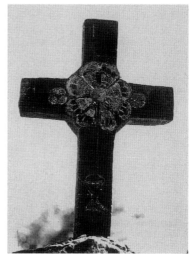

Figure 17

But I must interrupt for a moment to draw attention to another example that may support the argument I'm about to make concerning this carving. On the outer wall of the Augustinian *convento* compound at Malinalco, south-west of Mexico City, perhaps moved there from the middle of the old patio, still stands a small stone cross of nearly the same size as the Mayers' (figs. 17, 18). Its decoration is quite sparse except for three laterally ar-ranged flower motifs, two smaller four-petal blooms flanking a very large blossom with bits of obsidian inset in the eight petals joined around its disk-shaped ovule. Just above this ovule, another very tiny cross has been carved as if emerging between two equally tiny shriveled leaves. From the very center of the ovule just below, a thin double line of droplet forms runs straight down the post of the cross and links to the image of an undecorated chalice at the bottom. From the chalice bowl and connect-ing to this line of droplets the circular Host arises.

What is one to make of this strange configuration? To orthodox Roman Catho-lics, of course, the flower motif can simply be seen as a charming and innocently impromptu signifier for Jesus'

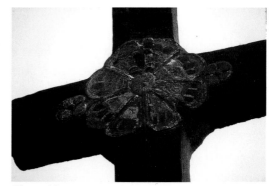

Figure 18

29

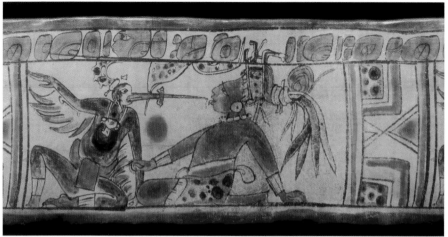

Figure 19

"sacred heart" from which his blood streams into the chalice where it, along with the wafer-shaped Host—Jesus' "body"—has been miraculously transubstantiated from the wine and bread of holy communion. On the other hand once again we might ask what a native Nahua Indian, even a Christian convert still recalling ancient indigenous lore, might read in these same symbols. Would not he or she be reminded of the preconquest metaphor of flower as human heart, from which sacrificial blood is drawn just as the hummingbird with its stiletto beak sucks nectar from a real blossom's nourishing center? A quite explicit depiction of this ancient Mesoamerican association can be seen on a ninth-century Maya vase showing an anthropomorphic hummingbird whose long beak skewers a flower and simultaneously draws blood from the lip of a seated lord (fig. 19).[11]

Moreover, a Nahua farmer would surely recognize that the diminutive cross above the flower center actually shows a young seedling emerging like a bean sprout from a splitting dicot, thus implying that the Christian cross as world tree likewise grew from a sacred seed nourished by the same sacrificial blood as pours forth from the flower's ovular "heart."[12] The Augustinian friars at Malinalco must have participated in open collusion with their indigenous artist, deliberately co-opting his pagan metaphors in order to explain the mystery of that most esoteric of all the Christian sacraments in terms that the Indians could more expediently understand.

I suggest that the creative sculptor of the Mayer cross was also think-ing of these same traditional flower and blood-fertilized seed metaphors when he carved his own version of the Christian chalice, but this time the chalice itself became the blossoming flower from which Christians im-bibe, just like the sucking hummingbird, the "nectar" of Jesus' blood. Furthermore, I believe he positioned his flower-like chalice at the foot of the cross, almost as surrogate for the skull image usually in this place, in order to emphasize its analogy to the sprouting maize, ever regenerating from seed made fertile by sacrificed blood, thus signifying Christian resur-rection and redemption.

There is ample evidence that flower metaphors played an important role in native religious life well after the "spiritual conquest" and were even encouraged by the missionary friars. In the Testerian manuscript of the "Lord's Prayer" (fig. 7), for example, the friar scribe ("Dom. Lucas Matheo escrivano") who composed it in the early seventeenth century added a unique flourish that was surely intended to appeal to Indian neo-phytes. In the uppermost register on the right, just after the glyphs that gloss "Thy kingdom come, thy will be done on earth as it is in heaven" (a Latin scripted translation in the native Nahua language is overwritten), and just before "Give us this day our daily bread" in the register below, the scribe inserted an unprecedented collocation—a raised hand, a figure of a lordly person smelling a flower, and a circle with a cross on top and a bar with flowers running across it—that has been deciphered as meaning, "God enjoys the flowers on earth; therefore let flowers multiply in the universe." [13] Louise Burkhart has documented further how Nahua-speak-ing Indians conflated their ancient concept of a flower-filled paradise with the Christian heaven (Burkhart 1992, 88–110), especially in association with the spreading cult of the Virgin Mary in Mexico (Burkhart 2001, 20).

The native sculptor of the Acolman cross (fig. 9) was also attempting to make some similar reference, if not to flowers *per se*, at least to the notion of the seed as metaphor of resurrection. At the bottom of his cross beside the lance that pierced Christ's side, he placed the skull of Adam resting on his coffin-lid. This was of course a canonical represen-tation, but under this, on the second step of the three-step pedestal below

the cross, the sculptor carved a small image of the Virgin Mary's upper torso in high relief. Her appearance here hews to Christian tradition, since the mother of Jesus was often shown weeping at the foot of the cross, but this version seems less representational and more iconographic, in a manner consistent with its placement among the passion instruments. Her hands are crossed below her breast, and just above and between them the sculptor cut a small disk representing either her heart or, as I would interpret it, a seed, that is to say, the embryo of Jesus. If this detail did represent a heart it would certainly be unique, because, unlike Jesus' bleeding heart, Mary's is hardly mentioned in Christian iconography. On the other hand, if signifying a seed, it would be quite relevant to one of the issues most discussed in Marian theology during the late Middle Ages, namely, the nature of her divine fecundation. Not only churchmen but also artists puzzled over how to describe the way God's "seed" entered the Virgin's womb (Steinberg and Edgerton 1987). A common simile was to liken this miracle to the passage of light without trace though transparent glass. God's "seed" was often symbolized by a dove, the "Holy Spirit" shown in *Annunciation* paintings descending from heaven and flying in the direction of the Virgin's body. Fig. 20, for example, shows an early fifteenth-century Italian painting of this commonplace subject. The Church, while denying that Mary, ever inviolate, could have had sexual intercourse in

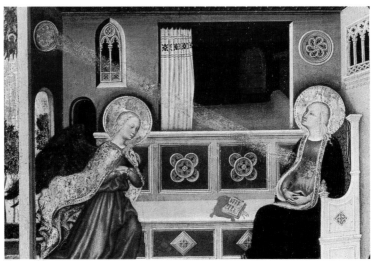

Figure 20

the usual manner, was just as dogmatic in insisting that Jesus gestated from an embryo in her womb as in any normal female pregnancy.[14]

The diminutive sculpture of the Virgin on the Acolman cross actually sits against a small stone tabernacle, open at one end, in which the Indians could place sacred offerings, perhaps even real seeds of maize. Just beneath this tabernacle and almost at ground level, the artist carved a second tiny skull, and beside it left some unfinished work including another larger rounded disk out of which something seems to be protruding onto the Virgin's dress, and under that a form that could be either a serpent or a root. Indeed, in these shapes the artist appears to have been trying to develop some never-quite-resolved combination of skulls and seeds.

According to native Mexican tradition, human skulls signify not just death and oblivion, as we in the modern West too often assume, but death and rebirth, just as the seed of the last autumn's dead plant assures its regeneration in the following spring (Furst 1982). Such is the message of the remarkable maize-producing world tree image in the Codex Borgia (fig. 4), where we observe two kernel-tipped, knife-shaped maize cobs thrust into the split-open chest of a skeletal deiform buried in the center of the universe, signified here by a set of earth-colored concentric rings beside its bony body. Out of the skeleton's cleft rib cage the tree springs. Flanking the tree, two full-fleshed male figures further fertilize it with blood spurting from their perforated penises. Skulls and skeletons as symbols of death and resurrection (although no longer associated with blood and sacrifice) are still ubiquitously displayed everywhere in Mexico, especially celebrated each year during the colorful *Día de los Muertos* holiday on November 1.

Finally, we return to the Mayer cross to consider its most curious yet perhaps most pregnant relief image. On the back side of the cross at the very base, exactly opposite the chalice on the lower front, the artist represented what appears to be a small tree or tree branch (fig. 21). There can be no doubt that he intended to depict a growing plant form here, but what kind, and why in this place?

The first question I think can be answered by presuming that our inventive artist did not mean it to appear as a specific plant but rather as a

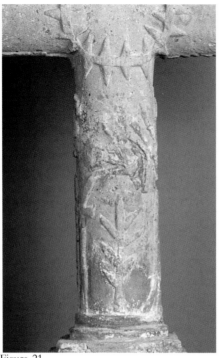

Figure 21

generic one symbolizing collectively all the sacred tree metaphors he had ever heard about during his life, both as an indigenous Mexican Indian and as a Christian neophyte educated by the European friars. On the latter assumption, his schematic icon could simply be interpreted as standing for any or all of the following: the palm of Jesus' martyrdom, the Cedars of Lebanon, the Tree of Knowledge or Life in the Garden of Eden, the flowering staff of Joseph, or even the "Tree of Jesse," the so-called family tree representing Jesus' lineal descent through Mary from the house of David.

From the sculptor's native point of view, on the other hand, and in answer to my second question—why here?—I believe there can be no doubt that he intended a spiritual link between the chalice-as-flowering-seed he carved on the front of the cross, and the plant image he carved directly behind. Perhaps in his mind's eye this latter should even represent a stalk of maize. In any case, both front and back icons must be seen as sprouting together from the same earth at the foot of the grounded cross. The chalice, observed in front, initiates the miraculous process by which the sacred seed of regeneration is fertilized by Jesus' descending blood; the burgeoning plant behind is the result of that fertilization, no less than the young world tree—Christ himself—reborn from his own divinely impregnated earth, and, like the eternal maize, being regenerated again and again in a never-ending cycle of life and death.

If my reading of these various connected and disconnected icons depicted on the Mayer patio cross is even partly correct, then we have here an eloquent testimonial of what I, along with many scholars, have

recently come to understand regarding what really happened during the sixteenth-century "spiritual conquest" of Mexico: not so much a total replacement of ancient native American religious customs by a completely different, European-Christian set of dogmas, not so much a superficial and sullen acceptance of these foreign doctrines that many Indians undermined by secretly reintroducing subversive pagan rituals and motifs (the "idol behind the altar"), but rather what Louise Burkhart (2001, 4) has described as a more subtle accommodation, in which the Indians even under colonial oppression

> saw no contradiction in reevaluating both Christian and traditional practices and discourses and concocting from them new formulae, for the most part consistent with accustomed modes of eliciting sacred experience, that suited their colonial circumstances at any particular time and place. Thus Nahua traditions became Nahua-Christian traditions.

Allow me to conclude by paraphrasing another quotation, this time from James Lockhart (1992, 446), that not only cogently sums up the hybrid religious institution that seems to have successfully endured to this day among the surviving indigenous peoples of Mexico, but also expresses the unique inventiveness of native artists like the carver of the Mayer cross who so ingeniously created "forms that can not be securely attributed to either original parent culture, but that were accepted all along as familiar to both. Even when the end result looked more Hispanic than indigenous, the Indians, without second thoughts and with good reason, regarded the concept and pattern as their own."

Notes

1 My thanks to H.B. Nicholson, Louise Burkhart, Eloise Quiñones Keber, Judy Sandoval, Donna Pierce, Walter Gibson, Naomi Smith, and Sid Hollander for their suggestions and comments in the preparation of this paper, and to Ann Daley and Jennifer Porter for providing the excellent photographs of the Mayer cross.

2 The huge cross in the patio of San José eventually began to teeter, threatening to fall on the nearby chapel, and so had to be cut down and replaced by a much shorter substitute, reduced, legend says, from a piece of the original's arm, while local Indian converts collected the chips as holy relics. Indeed, such gigantic wooden crosses not only were subject to collapsing, but also attracted lightning. The Mexican Church thereupon decreed that henceforth, all patio crosses be carved in permanent stone when possible, and scaled to more modest size because "the cross of Christ our Redeemer was not tall" (McAndrew 1965, 248).

3 Many photographs of patio crosses in their *convento* settings from all over Mexico have recently been donated by Judith Sandoval to the Fine Arts Library, Fogg Museum, Harvard University, Cambridge, Massachusetts.

4 See Schele 1995 for an excellent discussion of the continuous and nearly universal tradition of the "world tree" among all preconquest Mesoamerican societies, from the time of the Formative Olmec (1500–300 BC) through that of the Post-Classic Aztec (1325–1521 AD).

5 Only two possible exceptions have been documented. One, in the *convento* at Maní, Yucatan, shows both the cross and the crucified Jesus carved from a single block of stone; the other, at Zurumucapeo, Michoacán, has the body of Christ, now fragmented, attached as a separate piece to the stone cross (Sandoval 1968). There remains some doubt, however, that either of these was originally intended as a patio cross (McAndrew 1965, 250).

6 The standard studies of the *Arma Christi* and the "Mass of St. Gregory" are, respectively, Berliner 1955 and Endres 1917. Unfortunately, neither these nor the later basic essays by Schiller 1968/74 and Suckack 1977 say anything about the spread to the New World of Passion instrument iconography. For that, see Lara 1996, who argues that the proliferation of the latter in colonial Mexico had less to do with the contemporary popularity of the "Mass of St. Gregory" miracle than with the missionary friars' eschatological vision of the apocalyptic Second Coming.

7 See Lara 1996, who discusses the appearance of obsidian mirrors on some Mexican crosses in terms of the traditional Christian fascination with the symbolic mirror as reflection of divine creation and salvation (as in Vincent of Beauvais's thirteenth-century *Speculum maius*, for instance). Lara also mentions briefly the Indians' belief in the supernatural power of the obsidian mirror, and that the pagan deity Tezcatlipoca and the Mayan K'awiil bore it in their foreheads as a divine attribute. Lara also suggests that the round mirror in the patio cross might have signified the "Fifth Sun," according to Aztec legend the final age of human civilization, prophesied to end on

the fatal day Four Ollin in the Nahua calendar, and might thus have been another indigenous way of expressing the friars' apocalyptic vision. Nevertheless, whatever the syncretic syntheses of these Christo-pagan interpretations, anyone visiting the hybrid churches in indigenous Mexican and Guatemalan communities today quickly notices the mirrors (no longer made of obsidian but rather ordinary glass or shiny metal) ubiquitous on altars and effigies, thus important ritual instruments still in native Catholic religion.

8 The Sotheby Auction Catalogue of May 14–15, 1996, in referring to the provenance of the present Mayer cross, lists the earliest private owner as one Countess Odriozola, resident of the Mexican state of Hidalgo. If this is the area from which the cross originally came, then it probably also means that the cross was created under Augustinian auspices, since that order operated the most *conventos* in Hidalgo.

9 While some at the time maintained that the true column of the Flagellation was still in Jerusalem, the issue was resolved, more or less, when the Church proclaimed that Jesus was scourged not once but twice, again when he was taken to Pilate's house, and that the Santa Prassede column, also found in Jerusalem (by Cardinal Collona in 1223), must have been that second whipping post. Indeed, many of the artworks inspired by the Santa Prassede column were, like Murillo's painting, titled "Christ after the Flagellation" or "Christ at the Column," to distinguish them from the canonical scourging. According to Mâle (1932, 264), images of the Santa Prassede relic were not included among the standard instruments of the Passion until the seventeenth century. Since updated prints showing this addition would not have arrived in Mexico until even later, the Mayer cross in all likelihood must have been carved well after 1600. Interestingly, in his recent controversial film, "The Passion of the Christ," the director, Mel Gibson, chose to have Jesus tethered to the Santa Prassede column.

10 Louise Burkhart has discovered a Nahuatl reference to a similar indigenous Mexican ritual in which penitent performers would pierce their tongues with sticks and then offer the sticks, likewise covered with blood, to a deity image (Burkhart 2001, 54).

11 The association of flowers and hummingbirds with human blood sacrifice is another tradition shared by nearly all Mesoamerican societies. References to it are found in the native codices right up until the time of the conquest (in the central Mexican Codex Magliabecchianus and Codex Borgia, for instance).

12 The association of seed cotyledons and plant sprouts with the iconography of human creation and divine kingship in ancient Mesoamerica is demonstrated by Schele (1995, 106) and Reilly (1995, 39). Schele's evidence in particular derives from the work of her students, Virginia Fields and Matthew Looper, as cited in her notes (op.cit., 116).

13 For a fuller discussion of this manuscript, known as Egerton #2898 in the British Library and perhaps the most elaborate of all Testerian manuscripts, see Duverger 1996, 171–175; also see Normann 1985, 129–165, and Edgerton 2001, 28–30 (the author is no relation to the "Egerton" for whom the manuscript is named).

14 St. Antonine, the mid-fifteenth-century Dominican archbishop of Florence, who was well remembered by the missionary friars in the New World, and whose published writings were donated to the Colegio de Santa Cruz library, in Tlatelolco, Mexico, during the sixteenth century (Edgerton 2001, 111–113), was particularly concerned about the Virgin's fecundation. He adamantly denounced those theologians and their artist followers who claimed (and depicted) that Jesus descended from heaven as a fully developed *post partum* baby into the womb of Mary, without having gestated from fetus to infant in the normal human way. He even took advantage of Latin grammar to reinforce his explanation of the miracle of Jesus' conception, stating that Mary received God's seed *in utero*, which syntactically does not make sense. Had he suffixed the word in the proper accusative case, as *in uterum*, it would have meant that God's seed passed physically *into* her womb; that is, from outside to inside, whereas the ablative case that he did use, *in utero*, means that the seed was inside Mary's womb *a priori* with no physical change of place implied (Steinberg and Edgerton 1987).

Bibliography

Berliner, Rudolf. 1955. "Arma Christi." *Münchner Jahrbuch der bildenden Kunst* 6, no. 3:35–153.

Burkhart, Louise M. 1992. "Flowery Heaven: The Aesthetic of Paradise in Nahuatl Devotional Literature." *RES* 21:88–110.

————. 2001. *Before Guadalupe: The Virgin Mary in Early Colonial Literature.* Albany: Institute for Mesoamerican Studies, State University of New York at Albany.

Duverger, Christian. 1996. *La conversión de los indios de Nueva España.* Mexico City: Fondo de Cultura Económico.

Edgerton, Samuel Y. 2001. *Theaters of Conversion: Religious Architecture and Indian Artisans in Colonial Mexico* (with photographs by Jorge Pérez de Lara). Albuquerque: University of New Mexico Press.

Endres, J. A. 1917. "Die Darstellung der Gregorius Messe im Mittelalter." *Zeitschrift für christliche Kunst* 30:146–151.

Fernández, Miguel Angel. 1992. *La Jerusalén Indiana: Los conventos-fortaleza mexicana del siglo XVI* (with photographs by Bob Schalkwijk). Mexico City: Smurfit Carton y Papel de México, SA de CV.

Furst, Jill, and Leslie McKeever. 1982. "Skeletonization in Mixtec Art: A Reevaluation." In *The Art and Iconography of Late Post-Classic Central Mexico,* edited by E. Benson and E. Boone. Washington, DC: Dumbarton-Oaks.

Galván González, Manuel. 1978. *Arte virreinal en Michoacán* (with photographs by Judith Sandoval). Mexico City: Frente de Afirmación Hispanista.

Lafaye, Jacques. 1976. *Quetzalcoatl and Guadalupe: The Formation of Mexican National Consciousness, 1531–1813.* Translated by Benjamin Keen. Chicago: University of Chicago Press.

Lara, Jaime. 1996. "El espejo en la cruz: Una reflexión medieval sobre las cruces atriales mexicanas." *Anales del Instituto de Investigaciones Estéticas* 69:5–40.

Lockhart, James. 1992. *The Nahuas after the Conquest: A Social and Cultural History of the Indians of Central Mexico, Sixteenth through Eighteenth Centuries.* Stanford, CA: Stanford University Press.

McAndrew, John. 1965. *The Open-Air Churches of Sixteenth-Century Mexico: Atrios, Posas, Open Chapels and Other Studies.* Cambridge, MA: Harvard University Press.

Mâle, Émile. 1932. *L'art religieux après le concile de Trente: Étude sur l'iconographie de la fin du XVIe siécle, du XVIIe siécle Italie–France–Espagne–Flandres.* Paris: Armand Colin.

Normann, Anne Whited. 1985. "Testerian Codices: Hieroglyphic Catechisms

for Native Conversion in New Spain." Ph.D. diss., Tulane University; UMI #8515175, Ann Arbor, MI.

Parshall, Peter. 1999. "The Art of Memory and the Passion." *Art Bulletin* 81, no. 3: 456-472.

Reilly, F. Kent, III. 1995. "Art, Ritual, and Rulership in the Olmec World." In *The Olmec World: Ritual and Rulership*, edited by Michael D. Coe, 27–45. Princeton, NJ: Princeton Art Museum.

Sandoval, Judith (Hancock). 1968. "La cruz del atrio de San Angel Zurumucapeo." *Boletín INAH* 33 (September): 16–20.

Schele, Linda. 1995. "The Olmec Mountain and Tree of Creation in Mesoamerican Cosmology." In *The Olmec World: Ritual and Rulership*, edited by Michael D. Coe, 105–116. Princeton, NJ: Princeton Art Museum.

Schiller, Gertrud. 1974. *Iconography of Christian Art*. Vol. 2. 1968. Reprint, London: Lord Humphries.

Sotheby's Auction Catalogue: Latin American Art. 1996. New York: May 14–15.

Steinberg, Leo, and Samuel Y. Edgerton. 1987. "How Shall This Be? Reflections on Filippo Lippi's *Annunciation* in London." *Artibus et historiae* 16, no. 8:25–55.

Suckak, Robert. 1977. "Arma Christi: Überlegungen zur Zeichenhaftigkeit mittelalterlicher Andachtsbilder." *Städel-Jahrbuch* N.F.6:177–208.

Torquemada, Fray Juan de. 1615. *Monarquía Indiana*. Edited by Miguel León Portilla. 7 vols. Reprint, Mexico City: Instituto de Investigaciones Históricas, Universidad Nacional Autónoma de México, 1975–1983.

Wittkower, Rudolf. 1958. *Art and Architecture in Italy 1600–1750*. Baltimore: Penguin Books.

The papa su S...

ROSA

...co
...LATVR
OFFICIO
ET
MISSA.
BENED.
XIV.

Figures

Frontispiece Detail of figure 10.

Figure 1 Anonymous, *Virgin of Guadalupe*, sixteenth century, oil and tempera on cloth, 172 x 109 cm. Basilica of Guadalupe, Mexico City.

Figure 2 *Virgin of Guadalupe,* 1999, digital photograph. Los Angeles.

Figure 3 Anonymous, *Virgin of Guadalupe* (Spanish), late twelfth century, cedar, 59 cm. Sanctuary of the Monastery of Guadalupe, Extremadura, Spain.

Figure 4 Pedro de Angel, *Virgin of Guadalupe* (Spanish), 1550, engraving. Frontispiece for Gabriel de Talavera's *Historia de Nuestra Señora de Guadalupe,* 1597.

Figure 5 Baltasar de Echave Orio, *Virgin of Guadalupe*, 1606, oil on cloth, 170 x 111 cm. Private collection, Mexico.

Figure 6 Samuel Stradanus, *Indulgence for Alms toward the Erection of a Church Dedicated to the Virgin of Guadalupe*, c. 1613, copper engraving, 32.7 x 20.9 cm. The Metropolitan Museum of Art.

Figure 7 Detail of figure 6 (upper left).

Figure 8 José Juarez, *Virgin of Guadalupe with Apparitions*, 1656, oil on canvas, 210 x 295 cm. Convento de la Concepción, Agreda, Soria, Spain.

Figure 9 Nicolás Enríquez, *Virgin of Guadalupe with Apparition Scenes*, c. 1740, oil on copper, 33 ¼ x 25 in. Denver Art Museum, Collection of Frederick and Jan.Mayer.

Figure 10 Sebastián Salcedo, *Virgin of Guadalupe*, 1779, oil on copper, 24 1/4 x 19 in. Denver Art Museum.

Figure 11 Detail of figure 10, Vista of Guadalupe basilica and Tepeyac hill.

Figure 12 Sebastián Salcedo, *Virgin of Guadalupe*, 1793, oil on canvas, 95 x 75 cm. Museo Nacional del Virreinato, Tepotzotlán, Mexico.

Figure 13 Anonymous, *God the Father Painting the Virgin of Guadalupe*, 1750, oil on canvas, 86 x 63 cm. Museo Nacional de Arte, Mexico City.

Figure 14 Miguel Cabrera, *Virgin of Guadalupe*, 1766, oil on canvas, 172 x 105.1 cm. Museo de la Basílica de Guadalupe, Mexico City.

Figure 15 Detail of figure 14, "Tocada a su original en 28 de Octubre de 1766, Mich Cabrera Pinxit".

Figure 16 Miguel Cabrera, *Virgin of Guadalupe*, 1766, oil on canvas, 173.7 x 103 cm. Private collection.

The Reproducibility of the Sacred:
Simulacra of the Virgin of Guadalupe

Jeanette Favrot Peterson
Associate Professor
University of California, Santa Barbara

In 1999 several digitized photographs were produced of the titular icon of the Mexican Virgin of Guadalupe, now enshrined in the basilica of Guadalupe at the foot of Tepeyac hill, north of Mexico City. I will refer to this archetypal image as the *tilma* image, for, according to the well-known apparition legend first published in 1648, it was on the *tilma* or fabric cloak of a native, Juan Diego, that the image of the Virgin Mary was imprinted, transforming his private vision into a public sign and permanent relic (fig. 1). Exploiting the most modern of technologies, the photographs replicate the *tilma* image in every way, including her precise dimensions (fig. 2). However contemporary their production, very traditional methods were relied on to sanctify the digital Guadalupanas: they were taken to the basilica to be brought into physical contact with the

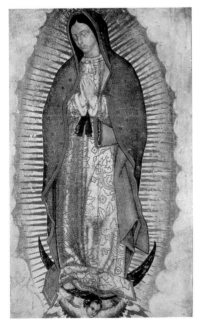

Figure 1

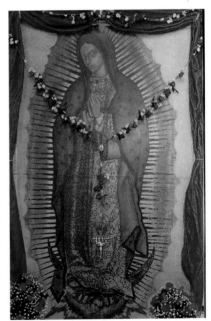

Figure 2

original *tilma* painting, and they were also blessed by the Pope. The replicated likenesses then went on a "pilgrimage," separate worldwide itineraries that began in 1999 and are ongoing to the present day. In each locale the digital pilgrim Virgins are housed in host churches and honored with special public ceremonies. Their reception, at times, has been tumultuous, attracting massive audiences, such as the 50,000 who crowded the Los Angeles Memorial Coliseum on December 11, 1999 to witness the digital Virgin of Guadalupe's triumphant entry and to celebrate a mass. An elaborate procession, with Aztec dance troupes, incense, and music, accompanied the ornately framed image as it was processed for several hours from a downtown Catholic church through the streets to the Coliseum. The image was greeted with emotional fervor; as it passed, worshippers tried to touch it, they wept, and some fell to their knees.[1] In other words, the digital copy of the Virgin of Guadalupe began to function as the archetype, being venerated in itself, receiving petitions, and, in some cases, being said to cause miraculous cures.

It is not the technology per se used in creating the Guadalupanas that is noteworthy here, for photography, and before that printmaking, have long been conscripted to produce portraits of sacred images and prayer cards for devotional use. While the startling verisimilitude of photographic copies is a significant component of their affective power, more telling is the authenticating process itself, the ritualized presentation of the copies and the heightened response that they engender in the devotees. It is in their public endorsement, through processions, spectacle, and official liturgy, that the full-blown replicas of Guadalupe are activated, i.e., brought to the same status as the *tilma* image, their efficacy dependent on each participant's values and beliefs.[2]

Walter Benjamin (1968) concludes that modern technology jeopardizes authenticity, that copies of an original work of art, once severed from that work's singular history, lose their "aura." I challenge his proposition, as the reproducibility of the Mexican Guadalupe does not diminish, but augments, the authenticity of the *tilma* image; moreover, many secondary copies continue to be converted into new objects of devotion for local communities.[3] Like the digital images, colonial copies performed their

sanctity in ritualized environments that endowed look-alike holy images with the mystique and authority of the originating icon. Benjamin (1968, 221) places a premium on that which is uniquely fabricated, polarizing the "plurality of copies for a unique existence." The reproducibility of the sacred is thus further complicated, since what is sacred is implicitly unique. Copies call into question the ontology of the sacred image when founded on the premise of a singularly favored person or object with ties to the supernatural. These claims of replicated sacrality, simultaneously unique and reproducible, fall within a time-honored phenomenon of the Christian tradition that recognizes the possibility of almost endless division, as in the parable of the multiplication of the loaves and fishes. Historically the power of the holy could be tangibly transferred to referential copies that, before the advent of mechanical reproduction, were the results of scrupulous manual craftsmanship.

The investiture of sacred power in duplicates raises a second fundamental issue which threads its way through this discussion, and that is the propensity of believers to conflate the venerated painting, sculpture, or photograph with its divine prototype, raising age-old charges of idolatry. In our contemporary example, the intense piety evoked by the digital Guadalupanas, in reality third-hand copies of a *tilma* copy of the celestial model, encourages transgressing the boundary between the representation of the sacred and its presence, allowing the sign to become, as Freedberg (1989, 31–32) expresses it, "the living embodiment of what it signifies." Questions of authorship also arise because most of the best-known late colonial painters in New Spain produced signed facsimile-copies of the Virgin of Guadalupe, establishing competing claims: artworks of individual human skill vs. visual manifestations of divine creativity.

In this essay I first examine how a sacred image attains the consecrated status of a wonder-working cult object and then follow the mechanics of reproducing its sacredness in multiple copies. My analysis straddles the Atlantic, as the Mexican and Spanish cults of the Virgin of Guadalupe are historically distinct yet culturally interdependent, sharing aspects of foundational legends and miracle stories and relying on similar theological beliefs and devotional practices. The parallels are helpful in

45

answering the basic question being posed: once the preternatural status of both Virgins of Guadalupe is established, how do we understand the mechanics of transferring the supernatural power of these two titular icons through simulacra? To a much greater degree than that of her Spanish namesake, the cult of the Mexican Virgin of Guadalupe was propagated through the proliferation of "facsimile copies" beginning early in the seventeenth century. Moreover, in their referentiality, multiple copies of the Guadalupe icon appropriated powers either as private devotional objects or as public cult objects that, in some cases, established powerful satellite shrines of their own. By the eighteenth century, the creation of manifold Guadalupanas throughout New Spain and beyond helped to legitimate the burgeoning nationalist ambitions of the creole class, for which the Virgin of Guadalupe had become a providential symbol. Multiple but sacred Guadalupanas became both commonplace and commodified, a central paradox in this essay.

The Tradition of *Praesentia*

The tradition of magically transferring sacred power through a surrogate is embedded in beliefs and practices of the early Christian church. From the fourth to the sixth centuries in the Mediterranean world of late antiquity, certain practices originated at the tombs of those individuals designated as holy men or saints. Described by Peter Brown (1981) as loci where Heaven and Earth met, the tombs rapidly became shrines that provided an opportunity to be in the presence of an invisible person of sacred stature. Permeated with *praesentia*, the "physical presence of the holy," the shrines and their occupants could continue to exercise that presence through fragments of the person's mortal remains or even objects that had made physical contact with the body or tomb (Brown 1981, 88). These "contact relics," in Brown's words, were believed to be full of *praesentia*, channels through which exemplary servants of God continued to work favors. If not an anatomical part of the departed saint, devotees could take with them pieces of cloth that had merely touched the tomb and leave with a souvenir so charged with extraordinary power that it could, in its own right, be invoked to work superhuman deeds.

46

Across medieval Europe there was an increasing demand for relics, whether bodily remains, shreds of clothing, or particles of collected dust, that were circulating as valuable commodities (Geary 1986).

By the sixth century there were reports that Christ had left bodily impressions on the column where he had been flagellated during his Passion and that there were foot imprints on the floor where he had been interrogated by Pilate (Kitzinger 1954, 104–105). From these impressions, *mensurae* or measurements were taken either by using cords, strips of cloth like measuring tapes, or by making wax impressions of these indexical remains of Christ's physical existence on earth (Kitzinger 1954, 105–106; Kuryluk 1991, 50). Like the tomb relics, these *mensurae* had powers of healing when placed on an ailing anatomical part or offered talismanic protection when worn about the neck. In representations of the holy, exact dimensions were perceived as the means of capturing a sacred essence. Careful measurements would continue to play a role in the mechanics of transferring sacrality; the measuring cords (known as *cintas* or *medidas* in Spanish) not only became separate talismanic artifacts, but also were used in creating true "portraits" of the original images of both the Spanish and the Mexican Virgins of Guadalupe. Like relics, the life histories of sacred images reveal how status and meaning are produced and reproduced.

The Spanish Virgin of Guadalupe: Miracles and *Medidas*

We begin with Guadalupe's Spanish namesake to explore how cult objects are invested with sacred power, accruing enough potency to be perceived as effective in intervening on behalf of their constituencies. As Benjamin (1968, 223) recognized, the construction of both truth-value and "aura" (authenticity) is dependent on embedding an original image in the "fabric of tradition." The Spanish Virgin of Guadalupe established important precedents for the foundational legends and miraculous powers of the Mexican Guadalupe as well as for the prescriptions that controlled the production of painted and sculpted copies of the cult image and her graphic likenesses.[4] Favored with royal patronage, the monastery of Guadalupe in Extremadura, western Spain, was the destination of a pow-

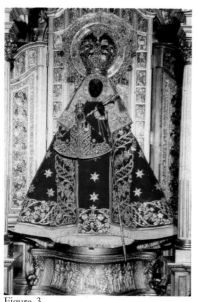
Figure 3

erful Marian pilgrimage. The Spanish Guadalupe is a late twelfth-century cedarwood sculpture of diminutive height (23", 59 cm.), one of a large corpus of European black madonnas (fig. 3; García 1993, 11–16). The black Guadalupe conforms to a genre of enthroned madonna and child sculptures, although at least since 1389, when the first inventory of clothing was made, the holy figures and the platform on which they are elevated have been camouflaged under tent-like brocade gowns.

During the Reconquest, Christian armies emblazoned Guadalupe's image on their military pendants to ensure victory. In the foundational account that accompanied her rising fortunes, the origins of the Spanish Guadalupe were traced to the evangelist Luke, endowing her with an antiquity far exceeding that of other Marian figures competing for the pilgrims' attention. According to the legend, St. Luke, by tradition a painter, was inspired to sculpt her when he had the "Virgin Mary in the flesh before his eyes, so that Spain would enjoy this unique and rich treasure unmerited by the rest of the world" (Montalvo 1631, fol. 12). Once completed, the portrait effigy was shipped from Pope Gregory in Rome to Sevilla, although by the eighth century Muslim invaders forced evacuation of the statue for safekeeping to the mountains of Extremadura, where it was hidden in a cave for 630 years. When a humble cowherd accidentally but providentially discovered the sculpture, intact and incorruptible, the Virgin Mary asked that an appropriate church be built for her and promptly also healed the cowherd's son to prove her divine pedigree (Montalvo 1631, fols. 1v.–4; Christian 1981a, 87–93, 276–279). Some of these ingredients, the worthy but lowly male protagonist, the Virgin's request for a home, and the cured family member, were part of other Marian legends in Spain known collectively as a "shepherd's cycle" and established the

pattern on which the Guadalupe apparition legend was formulated (Turner and Turner 1978, 41–57; Burkhart 1993).

In order to verify the *praesentia* of the Extremaduran Guadalupe, an impressive collection of miracle tales accumulated in the fifteenth century, and these were amplified and published as a book of miracles in an inventory of 150 recorded events, fifty for each of the preceding centuries (Talavera 1597, Bk. 5). In recognition of her prodigious reputation, grateful petitioners left both monetary gifts and symbolic mementos, including painted scenes or ex-votos of her miraculous interventions hung near her altar (Talavera 1597, 162v.–163). To protect this favored status and the rich flow of alms that accrued as a consequence, the singularity of the Virgin of Guadalupe was vigilantly protected against imitations.

Satellite shrines to Guadalupe established by the Jeronymite order, who were in control of the original shrine, were given explicit permission to replicate her sculpted image as long as a percentage of the donations was funneled back to the Extremaduran mother house (Christian 1981a, 87–88; Alvarez Alvarez 1993, 526–528). Even the graphics that were routinely produced by monasteries of the late fifteenth and sixteenth centuries were monopolized by the Jeronymites, with their proprietary rights to sell or give the paper prints in exchange for alms. In response to Jeronymite complaints that "improper" engravings outside their supervision were being fabricated elsewhere in the kingdom, Philip III issued a royal edict in 1602 granting to the monastery exclusive rights to produce and distribute all prints of the sacred image for the next decade.[5]

When the Jeronymite friar Diego de Ocaña left for the newly colonized Andean provinces in 1599 to establish outposts of Guadalupe worship, he took with him prints of the titular image to disseminate, including the popular 1550 woodcut by Pedro de Angel (fig. 4). Ocaña complained that the quantities of engravings sent to him in the Americas were never enough to meet the high demand.[6] With requests for sacred souvenirs from as far away as Caracas, the acts of the Extremaduran chapter meetings reflect the pressure to produce not only prints of the Virgin of Guadalupe, but also histories, medals, and *novenas*, sets of meditations intended for use over a nine-day period. In some cases, older prints were

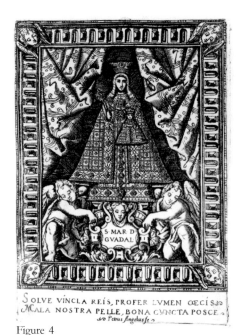

S OLVE VINCLA REIS, PROFER LVMEN ŒCÍ SJO
MALA NOSTRA PELLE, BONA CVNCTA POSCE
Jo Petrus Angelusft

Figure 4

reissued but "updated," with recent miracle stories intermingled with the beloved, well-worn stories of antiquity.[7] When the same friar Ocaña painted representations of the Spanish Guadalupe to establish new devotions in Peru and Bolivia,[8] he relied on the prints (and probably panel paintings) he carried with him to duplicate her proper features; however, the most crucial component in his reproduction process was size. In every image he created, which he called a "real original" (*verdadero original*) as distinct from just a portrait (*retrato*) of Guadalupe, Ocaña specifies that the figure is the same height and size as the one in Spain (*del mismo alto y tamaño de la de España*), capturing the numinosity of the original.[9]

In Ocaña's insistence on precise measurements, he was exercising the long-standing Christian practice of using *mensurae* to transfer the relic's originary power. The magical use of measurements was also manifest in the *medidas* or tapes (*cintas*) that were given or sold at medieval and early modern Marian shrines in Spain. Ribbons imprinted with the holy icon's image, sacred symbols, or name continue to be used in Spanish pilgrimage sites as both prophylactic and curing devices to touch or wind around the body parts that require divine protection or healing. Friar Ocaña carried with him *medidas* from the Extremaduran monastery, occasionally making gifts of them as relics (Ocaña 1969, 77–78). These he could have also used in designing his new Guadalupe images according to their exact and divine proportions.

The control of the mother house over the nature and distribution of likenesses began to weaken when the Spanish Virgin of Guadalupe was exported to the Americas, as distance diluted the ability to enforce copy-

right rules and the lucrative income that was expected did not materialize. In 1631, Diego de Montalvo (fols. 12v.–13), a Guadalupe historian, could still claim that the original icon was so majestic and awesomely perfect that it could not be copied even by the most talented artists. However, a century later, another historian lauded the "multitude of copies" that flooded Christendom with the portraits of the Sovereign Queen, whose images were "engendering such great faith and devotion in the souls of the faithful" (Francisco de San Joseph 1743, 203) and were themselves effecting miracles. This dramatic shift in permitting an almost profligate number of copies of the Spanish Guadalupe betrays the anxiety felt by the Jeronymite brothers in the face of their declining fortunes. Indeed, in response to the successful propagation of the devotion throughout the Americas and overseas, the Mexican Guadalupe cult was beginning to undermine worship of the older Guadalupe in Spain.[10]

Creating Authenticity: The Acheiropoietic Image of Guadalupe

For many of the conquistadors from Extremadura, Guadalupe was the Madonna of choice to provide them with the necessary spiritual armament in the conquest of the New World. Through small-scale effigies she sailed with the soldier-colonizers. Jeronymite friars were also sent to New Spain, yet devotion to the Spanish Virgin of Guadalupe there never made the substantial or lasting inroads that it did in South America. However, sometime before the mid-sixteenth century, a shrine dedicated to "Our Lady" was erected at Tepeyac, on the mainland just north of Tenochtitlan/Mexico City, which may have housed a small image, probably a sculpture of the Spanish Guadalupe. In addition, a painting on cloth of a Virgin Immaculate was installed in the Tepeyac shrine around 1555–1556, when a larger chapel was built.[11] One native chronicle and two sermons support the creation of the Guadalupe painting at this time by a noted native artist, probably one Marcos Cipac de Aquino, who was working in a Franciscan environment and also accepting independent commissions.[12]

The painting of 1555/56, which I am equating with the *tilma* image of Juan Diego, is 5'8" in height (173 cm.) on a support consisting of two

linen cloths sewn up with cotton thread (fig. 1). The canvas material and pigments are characteristic for an early colonial painting.[13] The Virgin Mary is shown standing on a crescent moon within a mandorla of solar rays, her iconography closely following the description of the apocalyptic woman in the Book of Revelation (12:1) who is "clothed with the sun and the moon under her feet." The image also relies on the iconography of the Tota Pulchra ("All Fair," from the verse in Song of Solomon 4:7) in which the purity of the Virgin Mary is conveyed through metaphorical symbols, such as the fountain and enclosed garden, as depicted in mural paintings from the same period in the monasteries of Huejotzingo, Puebla, and Metztitlán, Hidalgo. The popular theme of the "Assumption of the Virgin," with its analogous composition, may have additionally inspired Marcos's rendering. In short, the Mexican Virgin of Guadalupe was a composite, but streamlined, rendering of the Immaculate Conception as it was slowly standardized from a variety of sources over the course of the sixteenth century (Stratton 1994, 39–66). All of the elements evident in Guadalupe's composition, the oval mandorla of solar rays, the prayerful gesture and downcast head, the single angel caryatid, were anticipated in European graphic images from Germany, the Lowlands, and France that were circulating in Spain and carried to the New World.[14]

It is not until the early seventeenth century, with the first reliable images of the Mexican Guadalupe, that we can begin to reconstruct the beliefs and stories already circulating orally in the previous century. These include a conviction of her thaumaturgic powers and, as a corollary, a growing belief in the image's divine origins, both ingredients essential to her authentication as a reliable, working Marian icon.

Of the two earliest artworks to provide evidence for the legitimation of the Virgin of Guadalupe, the first is a 1606 painting signed and dated by the Spanish artist Baltasar de Echave Orio (c. 1548–1612; fig. 5). The painting is remarkably faithful to the *tilma* icon, including its proportions, its iconographic detailing, and the simulation of Guadalupe's two cloth panels sewn together at a vertical seam (Ortiz Vaquero 1988, 29). The painting also captures the twofold reality of a solid, hanging cloth tacked at the upper edges and the luminous image of Guadalupe, who is im-

printed on the textile surface yet appears to be impervious to its sway. Echave Orio is signaling the iconic status of Guadalupe as a singular and physical devotional work and, at the same time, suggesting that the image of the Virgin is acheiropoietic or "not painted by human hands." The artist makes a claim for the inherent mediating power of the sacred cloth itself, much as paintings of the head of Christ on Veronica's veil (the *vera icona* or *sudarium*) are images within an image.[15] The cloth veil, however, on which the traces of Christ's face were left by his sweat and blood after Veronica wiped his face on the road to Golgotha, is much like a xerox of Christ's face. The direct transfer of the divine through bodily contact in order to create a *vera* icon, or true image, is a process that Kitzinger (1954, 115) ironically has referred to as "mechanical reproduction," although it is not what Benjamin had in mind. Nor does this describe the type of acheiropoietic process claimed by the 1648 apparition legend, in which the image of the Mexican Guadalupe was said to have been celestially imprinted on Juan Diego's cloak, not of mortal manufacture. The ambiguity in the authorship of the Guadalupe painting was a challenge taken up by theologians and artists, as we shall see.

Seven years after Echave Orio's painting, the tantalizing hints of a belief in Guadalupe's divine authorship are convincingly linked to an expanding corpus of miracle stories in the 1613 Samuel Stradanus engraving (fig. 6).[16] To finance a lagging campaign for a new sanctuary, the newly installed archbishop, Juan Pérez de la Serna, commissioned from the Flemish artist a broadsheet that would advertise the Virgin of Guadalupe's prodigious powers. The central textual panel of the engraving details the fundraising purposes of the print and the benefits that

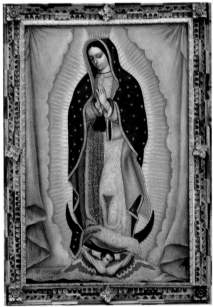

Figure 5

53

would accrue to generous donors, namely a grant of 40 days of indulgence, or relief from purgatory, in exchange for a donation.

Unlike Echave Orio, Stradanus depicts a fulsome Flemish Guadalupe as a free-floating vision; the cloth disappears altogether. Her powers are channeled through her presence in the lives of New Spain's inhabitants and through the implicit sacrality of her shrine-home and its environs, as can be seen in the miracle scenes that flank the image as well as in the tiny milagros, or body parts in silver, that hang above her altar, donated by successful and grateful petitioners. On either side, eight small ex-votos set the devotion firmly on American soil within a matrix of testimonials that verify the efficacy of the cult image. The second miraculous story on the left focuses on the healing of a nun, Catharina de Niehta, near the spring at the foot of Tepeyac hill and may be the most important for its antiquity, bicultural significance, and direct reference to the Virgin's apparition (fig. 7). As early as 1568, medicinal claims were made for the brackish waters of the natural spring near her shrine (Philips 1904, 419). Although the worn condition of the plate has erased some details, the vignette economically compresses time and space. Catharina is shown three times: at the well in the right background; in the middle ground where she awakens from the sleep induced by the curative waters; and, finally, front and center, gratefully kneeling before the Guadalupe altar. The textual caption that accompanies the picture records that "Catharina de Niehta had had dropsy for 11 years without

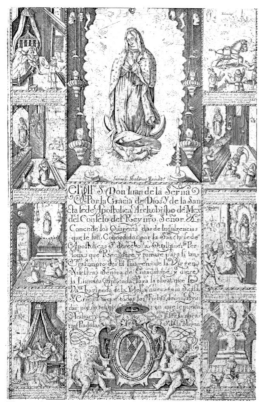

Figure 6

any hope of recovery. She came to *novenas* and drank the water from the fountain <u>where Guadalupe appeared</u> [*adonde se aparessió N. S. de Guadalupe*; emphasis mine]—and she was cured." The wording of the Stradanus text significantly states that Guadalupe "appeared" at the fountain, although it is unclear whether Guadalupe was sighted only by Catharina or whether this vision was part of the nascent Juan Diego apparition legend. A second allusion to a visionary experience of Guadalupe is related in miracle #5 (fig. 6; upper right), where the son of *hacendado* Antonio de Carbajal got his foot caught in the stirrup of a runaway horse and was saved only when "Our Lady appeared to him." In other words, it was only her presence that prevented his death. Stradanus represents Guadalupe floating heavenward, a figure now barely discernible in the upper left corner of the vignette.[17]

In the spirit of the Counter Reformation, the Stradanus engraving complies with the need for eyewitness testimony to provide an acceptable foundation of "truthful" data, grounded in specificity of protagonist and place. The images in the Stradanus share the burden of proof to authenticate Guadalupe as a genuine, not counterfeit, sign with potent agency. Once recorded, in word or picture, personal interventions enter the public domain and enact what Pilar Gonzalbo Aizpuru (1996, 52) has called a "spiritual complicity" between the shrine and the local populace.

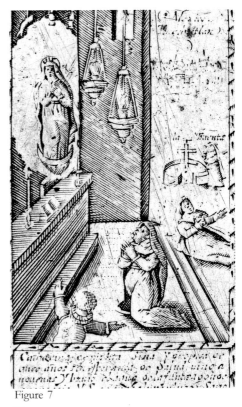

Figure 7

With the completion of a splendid new sanctuary in 1622 and the broadcasting of Guadalupe's efficacy through what I am suggesting was an ag-

gressive dissemination of the Stradanus broadsheet and other prints, nature intervened to further legitimate this Virgin Mary. Between 1629 and 1634, a prolonged period of flooding that peaked in 1631 paralyzed Mexico City and brought disease and death. In her first official communal function, the Virgin of Guadalupe was processed to the viceregal palace and then hung in the cathedral until the waters subsided and danger had passed.[18] With devotion to Guadalupe now also "flooding over," in the overblown analogy of Cayetano de Cabrera y Quintero, she was returned to her Tepeyac sanctuary in 1634 amid delirious festivities, including fireworks and theatrical vignettes. Traversing a capital whose streets were arrayed like a garden, a flower-bedecked litter carried the *tilma* image to an emotional welcome and a celebratory rehanging in her own sanctuary (Cabrera y Quintero 1743, Bk. 3, #715–717), not unlike the reception of the digital Guadalupe in Los Angeles. If her role in mitigating the inundations brought her fame, her four-year absence from her Tepeyac home stimulated the manufacture of copies that her devotees could venerate at home.

Only a few dated paintings of the Virgin of Guadalupe have been identified from the first half of the seventeenth century; thus we have insufficient material evidence for the apparently high demand for replications.[19] Yet Miguel Sánchez (1648, fol. 40) in 1648 already remarks on the number of successful copies produced. Along with the good, however, went great numbers of bad reproductions, so many in fact that "mountains of these copies were filling the realm with deceptions," prompting fears that the false paintings were perverting the cult itself (Cabrera y Quintero 1743, Bk. 3, # 717). The "false" copies had not been brought into physical contact with the *tilma* image (Cabrera tells us that the artists "lied about touching the roses of the Sacred Image") and many flouted the ancient tradition of correct *mensurae*; deceptive copies were ill proportioned and scandalously incomplete, some painted without the Virgin's feet and others missing her head![20] Reproductions were so plentiful and apparently so poorly fashioned that in 1637 the cathedral chapter issued an edict intended to control their production and confiscate those of inferior quality. The true measurements of the titular Virgin of Guadalupe

were publicly posted on the door of the Mexico City cathedral along with the severe penalties meted out to careless artists. The shameless multiplication of Guadalupanas was attributed to the greed of individual artists, but unauthorized sales also diverted profits from the Church.

The Myth of Production

By the mid-seventeenth century, when apparitions and prodigious events were on the ascent and pressure was building for duplicating the *tilma* image of Guadalupe, the Church hierarchy recognized the growing popular devotion and officially legitimated the cult of the Virgin of Guadalupe by publishing her originary legend. In what Geary (1986, 186) calls the "myth of production," the church offered an explanation of how the image came to be and, in so doing, identified the source of its power. Fragments of an apparition legend that were undoubtedly already circulating in oral form and that were firmly anchored in European hagiography coalesced in the foundational accounts written in 1648 and 1649 by Miguel Sánchez and Luis Laso de la Vega.[21] As the first two in a series of treatises written by creole intellectuals and clerics in the seventeenth century, they began the campaign to legitimate the Virgin of Guadalupe as the primary Virgin in New Spain. Not only do Sánchez and Laso de la Vega provide Spanish and Nahuatl accounts of Guadalupe's appearances to Juan Diego, but they also guarantee her wonder-working energy with a "book of miracles," repeating many of the same episodes found in the earlier engraving by Samuel Stradanus.[22] Although these treatises are the first verifiable texts that elevate the Guadalupe image to a divine sign "not made by human hands," the works of art cited above presage these claims and strongly suggest an earlier canonization of the cult (Peterson, forthcoming a).

Drawing on the cult "charter" provided by Sánchez and Laso de la Vega, the earliest extant painting of the apparitions is by José Juárez (c. 1617–1661 or 1662), as important for its early date of 1656 as for its quality and grandiose size (fig. 8).[23] Juárez recreates the illusion of an altarpiece with a large central panel featuring the Virgin of Guadalupe, flanked by framed "wings" demarcating four apparition scenes. Said to

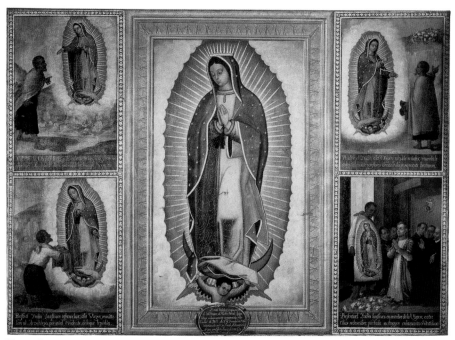

Figure 8

have taken place between December 9 and 12 in 1531, the apparitions are described in four scenes that are read from the upper left to the lower right in the painting. Juan Diego's initial encounter with the Virgin Mary on the rocky hill of Tepeyac (upper left) records the native's astonishment as the Virgin of Guadalupe descends from her heavenly abode transported on a radiant cloudbank. Juan Diego's Indianness is marked by a swarthy skin, bare feet, and the *tilma*, a typical Pre-Hispanic male garment worn tied across the shoulders; however, his bearded face, white shirt, and dark, loose pants signify his acculturated status. As both humble peasant and Christian neophyte, Juan Diego negotiates two worlds, an appropriate spokesperson to convey to Archbishop Juan de Zumárraga the Virgin Mary's wish to have a church built for her, echoing the Spanish Guadalupe's request.

At this still experimental stage, Juárez omits what will become the conventional second encounter where Juan Diego tries to avoid the Virgin; instead, the artist divides the third apparition into two separate episodes. In scene #2 (upper right) Juan Diego asks for "signs" (*le pide señales*) to convince the skeptical church authorities of the veracity of the

58

divine request. Those signs take the form of roses miraculously bloom-
ing in the middle of winter that are gathered by Juan Diego in the folds of
his cloak (lower left). The climax of the story (lower right) takes place
within the grandeur of the episcopal palace. As Juan Diego spills forth
the roses, they are replaced by the likeness of the Virgin Mary miracu-
lously imprinted on his outstretched mantle. The vaporous apparition is
remapped on a flattened cloth, and Guadalupe's previously animated ges-
tures congeal into her familiar iconic pose. Not only do the apparition
scenes betray an incipient stage in the telling of the legend that was not
codified pictorially, but the artist also feels the need to incorporate textual
captions to explain a narrative not yet familiar to a broad audience.

This altarpiece-like work was painted in New Spain by a Mexican
artist but was destined for a Conceptionist convent in Agreda, Spain, re-
nowned as the home of the mystic nun Sor María de Jesús Agreda, who
was abbess at the installation of the painting.[24] For Sor María, as for many
Catholics in Spain, the Juan Diego story must have had special resonance,
offering proof that prodigious events occurred in the Americas even as
they were recorded with increasing frequency in Counter-Reformation
Europe. To this was added the protonationalist movement of Guadalupe's
creole proponents, who were seeking a unifying symbol in an American
Virgin to galvanize supporters and legitimate their cause. It could not
have been entirely fortuitous that Juárez, native born and one of the found-
ing artists in the Mexican school, was among the first to represent
Guadalupe's wondrous appearances.

José Juárez also played a pioneering role in the production of
Guadalupanas for export, each inscribed with guarantees of authenticity.
Below the central panel of Juárez's painting, an inscription pronounces
this rendering as a "true portrait and exacting copy of the Image" (*retrato
verdadero y copia puntual de la Ymagen*) and also alludes to the transfer of
miraculous power through having the canvas physically "touched to the
original" (*tocada al orijinal*). In other words, it was not enough to have
duplicated the Guadalupe *tilma* image in paint; in the time-honored tradi-
tion of *praesentia*, the intermediary needed to be brought into physical
contact with the originary source of power. The process is graphically

59

described by Miguel Cabrera (1756, 2–3), who, during one of the infrequent openings of the glass case that protected the *tilma* painting, witnessed a two-hour period in which rosaries, medals, and at least five hundred images were brought to the sanctuary to touch the cloth.

The Agreda work was in the vanguard of the "True Copies" of miracleworking Guadalupanas that would soon swell to a flood of exports. Engravings with the apparitions of Guadalupe were printed in Flanders as early as 1655, and in 1688 Francisco Florencia could claim, with only a small degree of hyperbole, that no church in Mexico was without an altar dedicated to Guadalupe.[25] By the eighteenth century, medals, prints, and

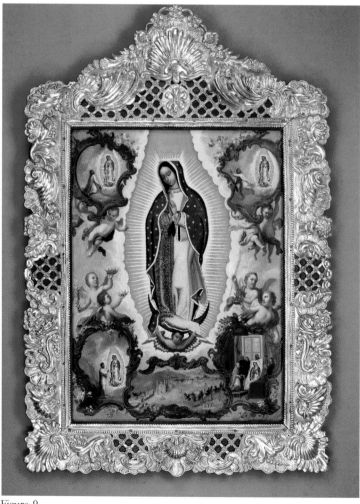

Figure 9

devotional paintings disseminated the cult to Rome and throughout Spain, Germany, and France. Two exquisite eighteenth-century works in the Denver Art Museum's collection, one by Nicolás Enríquez (active 1730s–1770s; fig. 9) and the other by Sebastián Salcedo (active 1770s–1780s; fig. 10), demonstrate the widespread demand for the pictorial evidence of Guadalupe's miraculous appearances, testimony of her advocacy for New Spain. Between two and three feet in height and more resistant to damage than canvas, both of these small-scale oil paintings on copper were eminently portable. Just as Guadalupanas were being exported overseas, so the Salcedo copper made the ambitious dusty journey overland to the northern frontier of the Spanish empire, where it was hung in a sanctuary newly dedicated to Guadalupe in Santa Fe, New Mexico (Pierce 1992, 90).

In his telling of the legend in 1775 for audiences by now well versed in the apparition story, Nicolás Enríquez (fig. 9) eliminates the explanatory texts included by Juárez a century earlier (fig. 8). Enríquez also dispenses with the earlier geometric compositions and rather conservative, didactic manner to adopt a more buoyant and decoratively elegant style. With rococo flourish and delicacy, Enríquez miniaturizes the episodes and embeds them in arabesque frames, floral garlands, and charming pirouetting angels. The four apparition scenes, however, follow a prescribed format reading from upper left to right and then from lower left to right, ending in the lower right-hand corner with the display of Juan Diego's cloak to an astonished Bishop Zumárraga. The opulence of the silver frame that garnishes the Enríquez reflects the silver boom that fueled artistic productivity in eighteenth-century Latin America.

Four years later, Sebastián Salcedo created a painting on copper with an even more florid composition that celebrates the official recognition of the Guadalupe cult in 1754 by Pope Benedict XIV, who is represented in the lower left holding a text confirming the office and mass to Guadalupe (fig. 10 and frontispiece this chapter). Based on a complex German engraving by two brothers, Joseph and and Johann Klauber, the painting makes presumptive claims.[26] Not only is the American Virgin Mary equal among the patriarchs, prophets, and angels, who rotate around her, including King David with his lyre in the upper right, but, in an inscription

under her feet, she is pronounced "Queen of all the Saints" (*Regina S.S. Omnium*). In addition to the four apparition scenes that flank Guadalupe's image, Salcedo, following the Klaubers' print, appends above her head three communal miracles that are opportunities for Guadalupe to demonstrate her love for and loyalty to all her constituencies in New Spain. In the central ornately framed vignette, a sailing ship is being tossed in a stormy sea, possibly the ship captained by García Montaño that was endangered for eleven days by a tempest until the vessel found safe harbor in Veracruz. Recognition of the crew's salvation was painted on a tablet, an ex-voto hung in the Guadalupe sanctuary in 1685 (Florencia 1688, fols. 143–143v.), as were acknowledgments of other interventions by Guadalupe in dangerous ocean voyages. In the scene on the upper left, the Virgin of Guadalupe is represented quelling a plague, almost certainly the devastating epidemic of 1737 that swept through the basin of Mexico

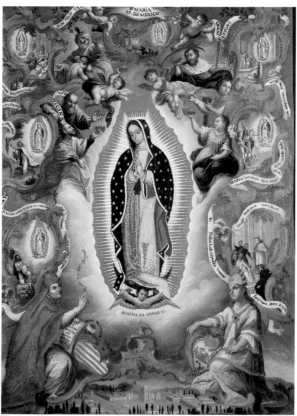

Figure 10

Figure 11

and Tlaxcala, its heavy toll represented by the skeletal grim reaper.[27] It was her apparent success in eventually suppressing the epidemic that catapulted the Virgin of Guadalupe into first place above all other devotions and led to her being proclaimed Patroness of New Spain (Cabrera y Quintero 1746, #899–903).

The events of 1737 unleashed scores of panegyric sermons on Guadalupe as well as celebrations of unabashed criollismo (Poole 1995, 177, 218). When Pope Benedict IV confirmed her role as patroness (*patronato)* in Rome, he was shown a copy of the Guadalupe *tilma* image by the famed Mexican painter Miguel Cabrera, an experience so gripping that he putatively exclaimed, "*Non fecit taliter omni nationi*" (He [the Lord] has not dealt thus with any other nation), the biblical verse from Psalm 147:20 written on the uppermost phylactery of the Salcedo painting. Although the papal benediction merely endorsed a phrase already associated with the Virgin of Guadalupe,[28] it is significant that it was a painted facsimile that inspired this prophetic utterance, one that confirmed Mexicans as the chosen peoples.

To further link creole nationalism to the Virgin of Guadalupe and underscore her American identity, both Enríquez and Salcedo replaced the Latin legend found at the base of the Klaubers' print with aerial views of the "new" 1709 basilica, recognizable by its four corner towers, and behind it Tepeyac hill (fig. 11). In other words, for the abstract text of Guadalupe's origins they substituted the physicality of a localized geography. Particularly common in works slated for distant places, these

Guadalupana landscapes served as reminders of the cult's roots. The importance of anchoring Guadalupe to Mexico is fortified allegorically in the lower right-hand corner of the Salcedo work with an indigenous noble-woman holding an Aztec *macquahuitl* or sword with obsidian blades. As the personification of the New World, she is dressed in a hybrid indig-enous-European costume, and she holds a shield featuring the toponym of Tenochtitlan (place of the nopal cactus on a rock) embedded in the image of the eagle with a snake in its beak perched on a prickly pear cactus, soon adopted as the national emblem of Mexico. The Salcedo composition is charged with imperial overtones, manifest through the var-ied regal headpieces, from the papal tiara to the red and gold European-style crown over the coat of arms of Mexico on the shield and its indig-enous counterpart, the feathered *colpilli* on the royal princess. Hovering over all is Guadalupe, crowned as the Queen of Heaven and being of-fered a surfeit of crowns; she blesses by her presence the symbol of a glorious Aztec imperium that, in turn, makes implicit reference to the independent creole patria or fatherland (Peterson 1992, 42–43).

In the reproducibility of the sacred, Salcedo's imitation of the Klaubers' engraving participates in another genealogy of images. The facility with which prints moved around the colonial world made them some of the most potent carriers of artistic and iconographic innovations as well as powerful tools for the spread of new religious ideologies. Just as the Stradanus broadsheet helped to shape the foundational treatises on Guadalupe by Sánchez and Laso de la Vega, so the Klaubers' engraving inspired many paintings and they, in turn, spawned other graphic copies, further propagating the cult.[29]

Mechanics of Transference

The mass manufacture of Guadalupanas by virtually every painter in New Spain, both modest and famous, promoted another category of works: the single portraits of the Virgin of Guadalupe labeled as "true portraits" or those that we can rightly call facsimile copies in their meticulous effort to duplicate the exact dimensions and features of the original *tilma* image. Throughout the evolution of Guadalupe iconography, the basic ingredi-

ents of the *tilma* icon remained substantially unchanged, its very familiarity an essential part of its evocative reception. As early as the 1656 Agreda painting by José Juárez (fig. 8), artists appear to have developed copying methods that would both standardize and speed the process of reproduction. In addition to the careful replication of the Guadalupe in the central panel, Juárez also maintains her integrity even while reversing the Virgin's pose in each of the four apparition scenes, which suggests reliance on some mechanical device.

However, the first secure indication that a master pattern of Guadalupe existed appeared during the early career of Juan Correa (c. 1646–1716), when he began producing Guadalupanas in the 1660s (Vargas Lugo 1994; Peterson 1999). According to his student José de Ibarra, who saw Correa using a waxed paper templette of the Virgin of Guadalupe, it allowed the artist to capture the tracing of "all her outlines, design and the number of stars and solar rays" (Cabrera 1756, 10). Ibarra further asserts that the templette, which he himself had handled, gave rise to other similar patterns without which, in his opinion, artists were capable of producing only substandard copies. Although manual tracings lack the same degree of verisimilitude as the nineteenth-century reproductive process of photography so lamented by Benjamin, the intent was identical, to create a perfect likeness. The exemplary copy produced was perceived as having the potential to embody the same holy properties as the original. Since *mensurae*, or the measurements of the original, were said to be inherently powerful, the iteration of the titular image of Guadalupe through the mechanics of measured tracings allowed the "facsimile-copy" to absorb and prolong the experience of the sacred. Even with some painters producing Guadalupanas full-time and using the correct *medidas*, however, the seventeenth-century Jesuit Francisco Florencia (1688, fols. 99-99v.) warned that only rarely did copies resemble the original. He also commented that native artists were more successful in this endeavor, perhaps an attempt to further indigenize both the product and its production.

The orthodoxy of the Guadalupe image had to be preserved, but thorny copyright issues, with commercial implications, must have arisen to limit pirated images. Controlling fraudulent works had early on led to imposing

controls, as did the Church edict of 1637 discussed above. We know that the prerogative of examining the Virgin of Guadalupe by removing the protective crystal or glass was a privilege rarely afforded (Cabrera 1756, 2). If access was controlled, it appears likely that the use of the waxed paper templettes was itself restricted. Clearly works patterned on templettes gained in economic as well as spiritual currency.

More was at stake than the potency, and thus salability, of precisely calibrated Guadalupe paintings. The creole agenda called for severing the Mexican cult from its Spanish counterpart, one of many explicit ruptures with the mother country. Francisco Florencia (1688, fol. 100) contrasted the sculptural icon from Extremadura (*de bulto*) with the painted rendering in New Spain (*de pincel*). Further, he stated that while the Spanish Guadalupe was made by human hands, albeit saintly ones since it was attributed to St. Luke, the Mexican Guadalupe was "by a superior hand...because either the celestial angels copied it or it was painted by the very hand of the Virgin." Thus, the acheiropoietic nature of Guadalupe was a crucial distinction not only to differentiate her from other Marian figures but, more emphatically, to mark her enhanced status vis-à-vis the Spanish namesake.

The humble cloak that served as a sacred canvas for the divine figure had to be theologically explicated. I have argued that her heavenly origins were implicit in the 1606 rendering of the sacred cloth by Echave Orio (fig. 5) and probably before. In support of this interpretation are poetic allusions of the time; a poem by Captain Angel Betancourt of 1608 refers to God as the "true Praxiteles" of the Guadalupe image, and in 1634 several anonymous couplets discuss the Virgin as "painted by him who made Heaven and earth" (Poole 1995, 96–97). Needless to say, pinpointing the authorship of the *tilma* image was elusive, as is evident in Florencia's equivocation between angelic hands and the Virgin's own workmanship cited above. Searching for alternatives to the image as the Virgin Mary's self-portrait painted with flowers, Luis Becerra Tanco (1675, fols. 20–21v.) offers the more tortuous but "scientific" explanation that Guadalupe's shadow traced a mirror image, complete with the solar rays at her back, onto the cape of Juan Diego. Subsequently, the Virgin sent an angel to

flesh out her fragile shadow drawing and it is this angel-painter whose own portrait appears as a signature at the base of the Guadalupe *tilma* painting (Becerra Tanco 1675, fols. 25–25v.). The dilemma persisted, as eighteenth-century theologians and preachers vacillated in their explanations, ranging from the more traditional possibility that the Virgin Mary painted her own self-portrait using "brushes of fresh flowers" to the bolder assertions that the miraculous imprint was the "work of heaven."[30] It is telling that

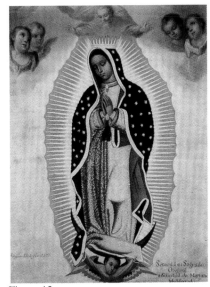

Figure 12

the nimbus of solar rays around the Virgin evolves pictorially from the self-contained oval of early representations (figs. 6, 8) to the chimney-like form with an elongated neck more common in later works (figs. 9–15). This funnel spins upward, opening to the celestial sphere above. In some instances, the "uterine mandorla," as Jaime Caudriello (2001, 67–71) has described it, is surmounted by the Dove of the Holy Spirit or God the Father, or both; the Godhead, with widespread arms and a downward gaze, appears to generate the Marian figure floating in the vortex below, as in another work by Sebastián Salcedo (fig. 12).

Flowers, more specifically the roses that bloomed on the stony hillside of Tepeyac in December of 1531, were often both the medium and the agent of the miraculous image; the *tilma* is described as the cloth "on which the flowers appear to have painted the sacred image."[31] The Rosa gallica or red rose was, along with the lily, the preeminent Marian symbol, its beauty and perfection a metaphor for the Virgin and its red color a premonition of the sacrificial blood shed by her son. In the apparition legend, roses were signs of the workings of the supernatural. Once gathered by Juan Diego into the folds of his mantle, the fragrant flowers were sanctified by the Virgin's physical touch and then returned to their cloth container (Florencia 1688, fol. 13v.). Just as the mediating Christian relic

Figure 13

transfers sanctity, the roses became the pigments and the transformative catalyst for a new embodiment of the sacred.

In a more sophisticated argument, buttressed by countless sermons of the period, the Trinity was advanced as the author of the *tilma* image (Cuadriello 2001, 141–179). In one anonymous eighteenth-century canvas, God the Father, palette and brushes in hand, is portrayed painting the Virgin of Guadalupe on a cloth held aloft by angels (fig. 13). Composed in a triangulated trinitarian schema are the heads of God, the Holy Ghost, and Jesus, who is slightly above and holds a rose in the same manner that God wields the paint brush.

If through mimesis the *tilma* image was an imitation of the Mother of God or the divine prototype, it, in turn, became the archetype or model for the countless reproductions that followed. These "true portraits," essentially copies of a copy, provoke further questions of authenticity when prominently signed and dated, as are the vast number of Guadalupanas produced by the most prolific artist of the eighteenth century, Miguel Cabrera (1695–1768). With the lavish patronage of Archbishop Rubio y Salinas and the Jesuit order, the Cabrera workshop flourished (Burke 1992, 158–174; Conde and Conde 1981, 146–154). It is not surprising that in 1751 Cabrera was asked to lead a team of six artists who analyzed the *tilma* in order to verify that it had not been painted by human hands. Publishing his findings in 1756 as *Maravilla americana*, Cabrera the artist correctly analyzes the material and the specific pigments (although he denies the use of any underpainting), but Cabrera, a citizen of his time and a faithful Guadalupano, concludes that the image is indeed an "American wonder."[32]

The assembly-line Guadalupanas that emerged from Cabrera's workshop both confirm and contest issues of authenticity in the reproducibility of the sacred, a tension born out of the competing claims of authorship, at once divine and human. A comparison of two Cabrera paintings produced in the same year of 1766 demonstrates the identical, mathematically accurate dimensions and iconographic details that result from using a templette (figs. 14–16). The scrupulous attention paid by the painter to measurements is sometimes textually inscribed on facsimile paintings. Although the premium was clearly

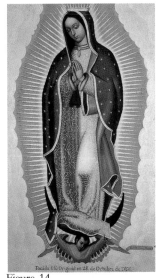

Tocáda à fu Original en 28. de Octubre de 1766.

Figure 14

placed on the image of Guadalupe, texts could function as a second signifying system, corroborating the authenticity of the iconic sign system (as in the Stradanus engraving).[33] Yet the startling differences between the two paintings in skin coloration and in the faces of the supportive cherubs bespeak workshop creations, perhaps entirely painted by Cabrera's assistants. Both are dated, have verifiable signatures of Cabrera, and state their claim to have been "touched to" the *tilma* image, thereby magically infusing the copies with a spark from the powerful cult icon (fig. 15).[34]

While the works are certified as authentic copies through their use of templettes, the signatures proclaim them as genuine Miguel Cabreras, conflating the archetype and the facsimile with the creativity of the artist.[35] These paintings are now triply authorized: (1) as authentic replications of the *tilma* image, (2) as objects whose potency is ensured by their physical contact with the original, and finally, (3) as creations of one of the most popular artists in the colonial period, whose signature alone—ironically perhaps the only touch of the master's hand—

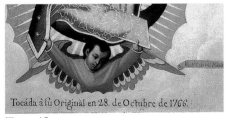

Tocáda à fu Original en 28. de Octubre de 1766.

Figure 15

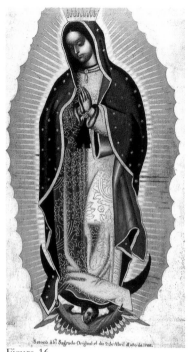

Figure 16

conferred status. If miraculous events, such as the apparition of Guadalupe, were interpreted as God's "signature" (Daston 1994, 265–266), artists could produce a facsimile-copy and duplicate this divine mark, while simultaneously, with their own signatures, boasting inspired achievements of their own.

In the replicas crafted after the Virgin of Guadalupe, authenticity was not dissipated, as Benjamin claimed for mechanical reproduction, but the original's "aura" could be effectively transmitted. By the late seventeenth and eighteenth centuries, the cult image entered a wider discursive field. Guadalupe was valorized not only as a sacred symbol and an emblem signifying certain sociopolitical ambitions, but also as a model for works of art that, as exacting copies, were highly remunerative. The proliferation of copies seeded the spread of the Guadalupe cult. Using the Virgin of Guadalupe as one of its primary rallying symbols, creole nationalism was linked to divine revelation and to an authentic American church, an enterprise in which colonial artists were active collaborators. The reproducibility of the sacred was redeployed for political and commercial ends, an ongoing phenomenon from the colonial-period templette to the present-day exploitation of digital technology.

Notes

1 Margaret Ramírez, *Los Angeles Times,* December 12, 1999. One of the photographed reproductions returned to Southern California in November 2001, to help inaugurate the newly completed cathedral in downtown Los Angeles, Our Lady of Angels. The exact number of blessed and thus authentic digital Guadalupes that are circulating is unclear, although the number three is most frequently cited. At least one digitized image was produced in 2000 by a company in Minneapolis, Minnesota, that was going to act as the master for producing and marketing both large and small reproductions whose sale and proceeds were ostensibly going to be divided between the cathedral in Mexico City and the new Los Angeles cathedral (*Reforma* January 29, 1999; *Reforma* August 7, 2000; *Reforma* December 1, 2001). This project was abandoned, as was the more recent scandalous agreement initially reached by the Archdiocese of Mexico City with a company in Orlando, Florida, for exclusive commercial rights to the Virgin of Guadalupe image over a period of five years in return for $12.5 million (*Proceso* February 9, 2003). I would like to acknowledge with gratitude Stafford Poole's thoughtful comments on an earlier draft of this paper, as well as the fruitful ideas on copies and authenticity exchanged with Ann J. Adams and Sarah P. Pittock.

2 These rituals reenact medieval consecration ceremonies, as described by Freedberg 1989, 82–83, 98; see also Vikan 1989, 50.

3 Freedberg (1989, 126) similarly revises Benjamin's thesis with regard to secondary copies of a sacred prototype.

4 On the structural patterns of the Spanish and Mexican Marian legends, see Christian 1981a, 1981b; Turner and Turner 1978; on the overseas transplantation of the cult of the Virgin of Guadalupe, consult Arturo Alvarez Alvarez 1993.

5 AHN Codice 1123B, fol. 188.

6 Ocaña 1969, 175, 177–178. Although several of the ten known sixteenth-century Jeronymite friars who made the trip to the Americas wrote back to the home monastery, none of their extant letters are as informative as the lengthy journal that Diego de Ocaña kept during his six-year travels throughout the Andean area of South America from 1599 to 1605.

7 AHN Codice 103B, fols. 74, 324v.

8 According to Ocaña's account, he produced at least seven cult images, for the communities of Lima, Cuzco, and Ica in Peru, as well as Potosí and Sucre in Bolivia. Although not a single verified original is extant, a close approximation is an eighteenth-century copy on silver in Sucre; see Arturo Alvarez, in Ocaña 1969, 444–445.

9 Ocaña 1969, 210, 168. Other images Ocaña (1969, 211, 288) fabricated of Guadalupe for purposes of setting up new devotions were also "small and dark" (*imagen pequeña y morena*) to reproduce both the size and the color of the Spanish archetype.

10 A good index of the growing interest in the immigrant Guadalupe cult is that Francisco de San José's 1743 history contains three chapters on the New World devotion.

11 On the native authorship and dating of the *tilma* painting, as well as Archbishop Montufar's patronage, see Edmundo O'Gorman 1986, 14–40, and Stafford Poole 1995, 49–68. On the possibility of two images in the shrine, an earlier Spanish Virgin of Guadalupe and the second the Mexican painting, see Jiménez Moreno 1958, 120–122.

12 The native chronicle is the "Anales de Juan Bautista," in Luis Reyes García 2001, and the sermons are recorded as the "Información de 1556," in Ernesto de la Torre and Ramiro Navarro de Anda 1982, 36–141; see also Poole 1995, 50–64.

13 José Sol Rosales, a Mexican conservator (INBA, Mexico), conducted scientific tests in 1982 and concluded that the "cloak" was of a linen-like sailcloth typically used in sixteenth- and seventeenth-century paintings (both European and colonial) as were the various tempera paints, including some with the addition of oil. This information was suppressed by the Church until the spring of 2002; see Rodrigo Vera, *Proceso* #1333, May 19, 2002.

14 Peterson, forthcoming b. The artistic models for the *tilma* image, its authorship, and its early history will be addressed in my book-length study on the iconography and function of the Spanish and Mexican Virgins of Guadalupe.

15 Hans Belting 1994, 428. On the complex history of the Edessa image beginning in the sixth century and evolving into the Veronica, see Ewa Kuryluk 1991, 114–144; Joseph Koerner 1993, 80–126; Belting 1994, 208–224. On the relationship of Echave Orio's 1606 Guadalupe painting and the Veronica, see also Cuadriello 2001, 185–187.

16 Samuel Stradanus (active ca. 1600–1630) is Latinized from the Flemish van der Straet, and should not be confused with the better known Joannes or Jan Stradanus, also called Jan van der Straet (1523–1604); he was working in New Spain by 1604 at least (Romero de Terreros 1948a and 1948b).

17 On the miracles in the Stradanus engraving, see Romero de Terreros 1948b; Fidel de Jesús Chauvet 1981, 44–45; Poole 1995, 118–124. A more detailed analysis of this copper engraving is found in Peterson, forthcoming a.

18 Cabrera y Quintero 1743, Bk. 3, #712–714. I have elected to use the numbered paragraphs from Cabrera y Quintero for cited references rather than his pagination, which is not dependably sequential. Sánchez (1648, fols. 61–61v.) also comments on the importance of the flood, pointing to the symbolic time span of a century between the appearance of the Virgin of Guadalupe in Mexico and her intercession at the peak of the inundations in 1631. On the repercussions of the flood for the Guadalupe cult, see also Stafford Poole 1995, 97–99, and Jacques Lafaye 1976, 254–255.

19 Elisa Vargas Lugo (1988, 76–80; figs. 48, 49, 52) has discovered three other Guadalupana artworks from this pre–1648 period, two of them signed and dated.

20 "*adulteró y amontonó tal copia de éstas, que se llenó el reino de engaños, y las copias que tenían cabeza y no pies, andaban ya sin pies ni cabeza*"; Cabrera y Quintero 1743, Bk. 3, # 717.

21 Brading (2001, 117–118, 342–360) appears to support the possibility of a pre-1648/49 Nahuatl account of the apparition legend. For a divergent view that securely traces its invention to the publications of Sánchez and Laso de la Vega, see Lisa Sousa et al. 1988, 43–47, passim. On establishing the historicity of the Virgin of Guadalupe by creole pro-apparitionist authors, also see Francisco de la Maza 1981 [1953]; Jacques Lafaye 1976; Poole 1995, 100–126, passim.

22 Three of the Stradanus ex-voto narratives are in Sánchez, and five additional stories duplicate miracles listed by Laso de la Vega; see Sousa et al. 1998, 13–18. The Stradanus engraving may have been one of the sources available to the creole apparitionists.

23 The José Juárez canvas is 210 by 295 cm. (6 1/2' x 9') and is described in Jaime Cuadriello 1994, 279–280; Patricia Andrés González 1999; and Peterson 2004. Miguel Sánchez's account of 1648 includes a graphic image of the fourth apparition, the earliest known. Paintings of the apparition scenes are documented for 1648 or 1649 (Florencia 1688, fol. 5v.), and by 1667 both the newly erected chapel on the top of Tepeyac hill and the sanctuary at its base had altarpiece paintings depicting the first and third apparitions respectively (Cabrera y Quintero 1743 Bk. 3, #731).

24 The prominence of Sor María de Agreda (1602–1665) lay in the quality of her theological tracts, her political eminence as confidante to Philip IV, and the tales of her miraculous journeys to the Americas, the so-called bilocation of Sor María to what is now the southwestern U.S.; for her biography see T. D. Kendrick 1967 and C. Colahan 1994.

25 Cayetano y Cabrera 1743, Bk 3, #671; Florencia 1688, fols. 179–179v., 182. On the increased traffic in Guadalupanas, see Cuadriello 1994, 261–265.

26 On the Salcedo see Pierce 1992, 90–92. On the Jesuit-commissioned engraving by Joseph and and Johann Klauber and its influence, see Cuadriello 1989, 76–79, where the eighteenth-century print "Exaltación del Patronato de la Virgen de Guadalupe sobre la Nueva Expaña" is also illustrated.

27 Another instance of the frequent near-tragic mishaps suffered by ocean-going vessels was that of a frigate sailing from Vera Cruz to Havana, which had been taking in water for five days until the Virgin of Guadalupe was invoked. Rodrigo de la Cruz gave a painted ex-voto commemorating this event to the Guadalupe sanctuary (San José 1743, 163). Salcedo depicts a third miracle in the right upper corner of his painting: the salvation of a man possessed with demons that have been cast out of his body and are represented as two tiny black figures tumbling into the jaws of Leviathan or Hell (Brading 2001, 116).

28 Florencia's (1688, fol. 34) use of the phrase "*Non fecit taliter omni nationi*" is a quotation from an anonymous Jesuit; see also Cuadriello 1989, 71. It should be noted that the copy seen by Pope Benedict IV was one of three created in 1752 in a collaborative effort by Miguel Cabrera, José de Alcibar, and José Ventura Arnáez; the one destined for the Pope was the "portrait with the greatest likeness" (*el retrato más*

parecido), according to José de Alcibar (Cabrera 1756, Letters of approbation, unpaginated). The two other copies were for Cabrera himself to keep in order to engender further duplicates, and—according to varying accounts—either for the archbishop, Manuel Rubio y Salinas, or for Ferdinand VI of Spain (Brading 2001, 133–35).

29 In addition to the Salcedo, other paintings based on the Klaubers' print include two oils by Juan Patricio Morlete Ruiz (1761 and 1772) in Xavier Moyssén 1988, 49–56, and a nineteenth-century lithograph by Igüíñiz, in Cuadriello 1989, 77.

30 Cabrera y Quintero, Bk 3, #561 and in verses after #759; Bk. 4, #902. A thorough discussion of Becerra Tanco's interest in optics and perspective can be found in Cuadriello 2001, 179–84. Brading (2001, 96–99, 146–168) offers a thoughtful synthesis of the many eighteenth-century sermons that revived scriptural and Neoplatonic theories of the image to aver, for example, that the *tilma* image of Guadalupe was a "copy of the divine idea of Mary."

31 Sánchez 1648, fol. 38v; repeated verbatim by Florencia (1688, fol. 28).

32 Miguel Cabrera's (1756, 1–5) assessment of the *tilma* image's nonhuman authorship rested in part on the impossibility of maintaining the delicate line and quality of the paint on such a rough cloth surface and its perfect conservation after hanging 252 years in a lakeside shrine having a salty, humid environment, an argument used repeatedly from the mid-seventeenth century on.

33 On medieval examples, see Alexander 1989. The base of a 1783 José de Alcibar oil of the Virgin of Guadalupe includes the inscription "*arreglada a las medidas*," in other words, patterned after the original measurements, including the precise number of solar rays and stars. The painting is in the collection of the Museo Regional de Guadalupe, Zacatecas, Mexico.

34 The two Cabrera paintings are inscribed with "*Tocada a su original en 28 de Otubre de 1766*; Mich Cabrera Pinxit" (fig. 15); and "*Se tocó a su Sagrado original el dia 2 de abril dl año de 1766;* Mic Cabrera f." (fig. 16).

35 Since this essay was submitted, Clara Bargellini (2004) has insightfully explored the dialectic between a strong tradition of copying and a drive for originality as New Spanish painters sought to improve the status of their profession; Bargellini also highlights Guadalupanas as a case study for these contradictory claims.

Bibliography

AHN: Archivo Histórico Nacional, Madrid

AHN Codice 103B, *Libro de los Actos Capitulares de esta Santa y real Casa de Guadalupe...* 1671-1802.

AHN Codice 1123B: *Licencia de Felipe III para que el monasterio o quien tenga su poder imprima por diez años y estampe la santa imagen de Nuestra Señora de Guadalupe*, Valladolid, December 22, 1602.

Alexander, Jonathan J. G. 1989. "Facsimiles, Copies, and Variations: The Relationship to the Model in Medieval and Renaissance European Illuminated Manuscripts." In *Retaining the Original: Multiple Originals, Copies, and Reproductions*, Studies in the History of Art, vol. 20, 61–72. Washington: National Gallery of Art.

Alvarez Alvarez, Arturo. 1993. "Guadalupe: dos imágenes bajo una advocación." In *Guadalupe: Siete siglos de fe y de cultura*, ed. Sebastián García, 523–533. Madrid: Ediciones Guadalupe.

Anales de Juan Bautista. Nahuatl ms. [1564–1569] in Archivo of the Basílica de N. S. de Guadalupe, Mexico City. (See also Reyes García.)

Andrés González, Patricia. 1999. "Un temprano cuadro de la Virgen de Guadalupe, con el ciclo aparicionista, en las Concepcionistas de Agreda (Soria)." *Anales del Museo de América* (Madrid) 7:237–247.

Bargellini, Clara. 2004. "Originality and Invention in the Painting of New Spain." In *Painting a New World: Mexican Art and Life, 1521-1821*, ed. Donna Pierce, Rogelio Ruiz Gomar, and Clara Bargellini, 79-91. Denver: Denver Art Museum.

Becerra Tanco, Luis. 1675. *Felicidad de México*. México: Viuda de Bernardo Calderón (Facsimile edition).

Belting, Hans. 1994. *Likeness and Presence*, trans. E. Jephcott. Chicago & London: University of Chicago Press.

Benjamin, Walter. 1968. "The Work of Art in the Age of Mechanical Reproduction," reprinted in *Illuminations*, 217–251. New York: Schocken Books.

Brading, D. A. 2001. *Mexican Phoenix. Our Lady of Guadalupe: Image and Tradition Across Five Centuries*. Cambridge: Cambridge University Press.

Brown, Peter. 1981. *The Cult of the Saints*. Chicago: University of Chicago Press.

Burke, Marcus.1992. *Pintura y escultura en Nueva España: El barroco*. México: Grupo Azabache.

Burkhart, Louise M. 1993. "The Cult of the Virgin of Guadalupe in Mexico." In *South and Meso-American Native Spirituality*, vol. 4 of *World Spirituality*, ed. Gary H. Gossen, 198–227. New York: Crossroad.

Cabrera, Miguel. 1756. *Maravilla americana y conjunto de Raras Maravillas...en la prodigiosa imagen de Nuestra Sra. de Guadalupe de México*. Facsimile edition, 1977. México: Editorial Jus.

Cabrera y Quintero, Cayetano de. 1746. *Escudo de armas de México: celestial protección...Ma. Santíssima en su portentosa imagen del Mexicano Guadalupe*. México: Vda. de D. Joseph Bernardo de Hogal.

Chauvet, Fidel de Jesús.1981. "Historia del culto Guadalupano." In *Album conmemorativo del 450 aniversario de las apariciones de Nra. Sra. de Guadalupe*, 17–82. México: Ed. Buena Nueva.

Christian, William A. 1981a. *Apparitions in Late Medieval and Renaissance Spain*. Princeton, NJ: Princeton University Press.

——. 1981b. *Local Religion in Sixteenth-Century Spain*. Princeton, NJ: Princeton University Press.

Colahan, Clark. 1994. *The Visions of Sor María de Agreda: Writing, Knowledge and Power*. Tucson & London: University of Arizona Press.

Conde, José Ignacio, and María Teresa Cervantes de Conde. 1981. "Nuestra Señora de Guadalupe en el arte." In *Album conmemorativo del 450 aniversario de las apariciones de Nra. Sra. de Guadalupe*, 121-223. México: Ed. Buena Nueva.

Cuadriello, Jaime. 1989. *Maravilla americana: Variantes de la iconografía guadalupana, s. XVII–XIX*. México: Patrimonio Cultural del Occidente.

——. 1994. "La propagación de las devociones novohispanas: Las guadalupanas y otras imágenes preferentes." *México en el mundo de las colecciones de arte* [Nueva España vol. 1], 256–299. México: El Gobierno de la República.

——. 2001. "El obrador trinitario o María de Guadalupe creada en idea, imagen y materia." In *El divino pintor: La creación de María de Guadalupe en el taller celestial*, 61-205. México: Museo de la Basílica de Guadalupe.

Daston, Lorraine. 1994. "Marvelous Facts and Miraculous Evidence in Early Modern Europe." In *Questions of Evidence: Proof, Practice and Persuasion across the Disciplines*, ed. James Chandler, Arnold L. Davidson, and Harry Harootunian, 243–274. Chicago: University of Chicago Press.

Florencia, Francisco de. 1688. *La estrella del norte de México*. México: Viuda de Juan de Ribera.

Freedberg, David. 1989. *The Power of Images*. Chicago & London: University of Chicago Press.

García, Sebastián, ed. 1993. *Guadalupe: Siete siglos de fe y de cultura*. Guadalupe: Ediciones Guadalupe.

Geary, Patrick. 1986. "Sacred Commodities: The Circulation of Medieval Relics." In *The Social Life of Things*, ed. Arjun Appadurai, 169–191. Cambridge & New York: Cambridge University Press.

Gonzalbo Aizpuru, Pilar. 1996. "Lo prodigioso cotidiano en los exvotos novohispanos." In *Dones y promesas: 500 años de arte ofrenda*, 47–63. México: Fundación Cultural Televisa, A. C.

Jiménez Moreno, Wigberto. 1958. *Estudios de historia colonial*. México: INAH.

Kendrick, T. D. 1967. *Mary of Agreda: The Life and Legend of a Spanish Nun*. London: Routledge and Kegan Paul.

Kitzinger, Ernst. 1954. "The Cult of Images in the Age before Iconoclasm." *Dumbarton Oaks Papers* 8, 83–150. Cambridge, Mass.: Harvard University Press.

Koerner, Joseph Leo. 1993. *The Moment of Self-Portraiture in German Renaissance Art.* Chicago & London: University of Chicago Press.

Kuryluk, Ewa. 1991. *Veronica and Her Cloth.* Cambridge and Oxford: Basil Blackwell.

Lafaye, Jacques. 1976. *Quetzalcoatl and Guadalupe: The Formation of Mexican National Consciousness, 1532–1815*, trans. Benjamin Keen. Chicago: University of Chicago Press.

Lasso (Laso) de la Vega, Luis. 1926 [1649]. *Huei Tlamahuicoltica*, ed. and trans. Primo Feliciano Velázquez. México: Carreño e hijos, editores.

Maza, Francisco de la. 1981 [1953]. *El Guadalupanismo mexicano.* México: Fondo de Cultura Económica.

Montalvo, Diego de. 1631. *Venida de la soberana Virgen de Guadalupe a España.* Lisbon: Pedro Craesbeeck.

Moyssén, Xavier. 1988. "Notas sobre iconografía Guadalupana." In *Imágenes Guadalupanas: Cuatro siglos,* 49–56. México: Centro Cultural Arte Contemporaneo.

Ocaña, Diego de. 1969. *Un viaje fascinante por la América Hispana del siglo XVI,* ed. Arturo Alvarez. Madrid: Ed. Bailén.

O'Gorman, Edmundo. 1986. *Destierro de sombras.* México: Universidad Nacional Autónoma de México.

Ortiz Vaquero, Manuel. 1988. "Tres ejemplos de pintura Guadalupana." In *Imágenes Guadalupanas: Cuatro siglos,* 29–42. México: Centro Cultural Arte Contemporaneo.

Peterson, Jeanette Favrot. 1992. "The Virgin of Guadalupe: Symbol of Conquest or Liberation?" *Art Journal* 51, no. 4 (winter): 39-47.

———. 1999. "Juan Correa y la Virgen de Guadalupe." In *Los siglos de oro en los virreinatos de América 1550–1700,* 306–309. Madrid: Sociedad Estatal.

———. 2004. "The Virgin of Guadalupe with Apparitions by José Juárez [1656]." In *Painting a New World: Mexican Art and Life, 1521-1821*, ed. Donna Pierce, Rogelio Ruiz Gomar, and Clara Bargellini, 154–159. Denver: Denver Art Museum.

———. Forthcoming, a. "Canonizing a Cult: A Wonderworking Guadalupe for Seventeenth-century Mexico." In *Religion and Society in New Spain,* ed. Susan Schroeder. Scholarly Resources.

———. Forthcoming, b. "Creating the Virgin of Guadalupe: The Cloth, Artist and Sources in Sixteenth-Century New Spain." *The Americas.*

Philips, Miles. 1904. "The Voyage of Miles Philips, 1568." In *The Principal Navigations, Voyages and Discoveries of the English Nation* [1589], ed. Richard Hakluyt, vol. 9, 398–444. Glasgow: James MacLehose & Sons.

Pierce, Donna. 1992. *Cambios: The Spirit of Transformation in Spanish Colonial Art*, ed. Donna Pierce and Gabrielle Palmer. Santa Barbara: Santa Barbara Museum of Art & University of New Mexico Press.

Poole, Stafford. 1995. *Our Lady of Guadalupe: The Origins and Sources of a Mexican National Symbol: 1531–1797*. Tucson & London: University of Arizona Press.

Reyes García, Luis. 2001. *Anales de Juan Bautista*. México: Biblioteca Lorenzo Boturini, Insigne y Nacional Basílica de Guadalupe.

Romero de Terreros, Manuel. 1948a. *Samuel Stradano: Imagen de la Virgen Nuestra Señora de Guadalupe*. México: Ediciones Arte Mexicano.

———. 1948b. *Grabados y grabadores en la Nueva España*. México: Ediciones Arte Mexicano.

Sánchez, Miguel. 1648. *Imagen de la Virgen María Madre de Dios de Guadalupe*. México: Bernardo Calderón.

San José (Joseph), Francisco de. 1743. *Historia universal de la primitiva y milagrosa imagen de Nra. Señora de Guadalupe, fundación y grandezas de su santa casa…* Madrid: Antonio Marín.

Sousa, Lisa, Stafford Poole, and James Lockhart, eds. & trans. 1998. *The Story of Guadalupe: Luis Laso de la Vega's Huei tlamahuicoltica of 1649*. UCLA Latin American Studies, vol. 84. Stanford, CA: Stanford University Press.

Stratton, Suzanne L. 1994. *The Immaculate Conception in Spanish Art*. Cambridge: Cambridge University Press.

Talavera, Gabriel de. 1597. *Historia de Nuestra Señora de Guadalupe*. Toledo: Thomas de Guzmán.

Torre Villar, Ernesto de la, and Ramiro Navarro de Anda. 1982. *Testimonios históricos guadalupanos*. México: Fondo de Cultura Económica.

Turner, Victor, and Edith L. B. Turner. 1978. *Image and Pilgrimage in Christian Culture*. New York: Columbia University Press.

Vargas Lugo, Elisa. 1988. "Iconología Guadalupana." *Imágenes Guadalupanas: Cuatro siglos*, 57–178. México: Centro Cultural Arte Contemporaneo.

———. 1989. "Algunas notas más sobre iconografía Guadalupana." *Anales del Instituto de Investigaciones Estéticas*, 60, 59–66. México: UNAM.

———. 1994. "La devoción Guadalupana." *Juan Correa, su vida y su obra*, by Elisa Vargas Lugo and Guadalupe Victoria, T. IV, pt. 1: 265–304. México: UNAM.

Vikan, Gary. 1989. "Ruminations on Edible Icons: Originals and Copies in the Art of Byzantium." In *Retaining the Original: Multiple Originals, Copies, and Reproductions*, Studies in the History of Art, vol. 20, 47–59. Washington: National Gallery of Art.

Figures

Frontispiece Detail of Figure 6

Figure 1 Anonymous, *Portrait Series of the Pre-Hispanic Inka Dynasty and Don Francisco Pizarro,* nineteenth century. Denver Art Museum.

Figure 2 Anonymous, *Portrait of Don Marcos Chiguan Topa,* eighteenth century. Museo Arqueológico, Cuzco, Peru.

Figure 3 Anonymous, *Parish of Santiago* (detail), from the *Corpus Christi* series, 1674–1680. Museo de Arzobispo, Cuzco, Peru.

Figure 4 Anonymous, *Portrait of a Ñusta,* eighteenth century. Museo Arqueológico, Cuzco, Peru.

Figure 5 Anonymous, *Portrait of Don Alonso Chiguan Topa,* eighteenth century. Museo Arqueológico, Cuzco, Peru.

Figure 6 Anonymous, *Portrait of a Ñusta,* early nineteenth century. Denver Art Museum.

Figure 7 Anonymous, *The Three Magi* (detail of the Inka king), eighteenth century. Juli, Peru.

Inka Nobles:
Portraiture and Paradox in Colonial Peru

Carolyn Dean
Professor, History of Art and Visual Culture
University of California, Santa Cruz

Imagine walking into the eighteenth-century home of a member of the Inka (Inca) aristocracy in Cuzco, Peru, the former capital of the Pre-Hispanic Inka empire and home to many proud descendants of its ruling lineage throughout the Spanish colonial (and later) periods.[1] It might be a house like that of Doña Isabel Uypa Cuca Ñusta, whose will and inventory of goods reveal aspects of its interior.[2] In the front hall, visitors faced portraits of the royal dynasty from which she descended, painted reminders of her bloodline and heritage, canvas ghosts who haunted colonial Spanish officials because of the steadfast loyalty many indigenous Andeans felt for native (rather than Spanish) authority. In fact, such portraits were outlawed by the colonial government in the late eighteenth century because they were believed to foster rebellious sentiments in their indigenous owners and viewers. Because of this, colonial-period portraits of Inka nobles have been identified as part of an Andean renaissance, a revival of Pre-Hispanic culture that expressed pride in Inka (especially noble) heritage (Guido 1941, 18; Rowe 1951; Rowe 1954, 18ff). It has also been argued, however, that because such images were derived from the European practice of portraiture, employing non-Andean modes of representation, they merely permitted the Inkas to celebrate their Indian heritage "in such a way as to inculcate passive acquiescence to Spanish rule" (Cummins 1991, 208). In other words, because it is within, and by means of, European portrait conventions that their identities are generated and conveyed, the subjects are but reflections of the European culture that has subsumed them. This essay argues that both interpretations are not only possible, but also likely, for these portraits simultaneously characterized Andean nobility as subjugated leaders (both rulers and ruled) and situated their subjects paradoxically in between and as part of both Andean and European worlds.

81

While painted portraits in oil on canvas were standard features of early modern European homes (especially those of society's elites), portraiture—physiognomic likenesses of known individuals—had no Inka history before the Spanish invasion (Dean, forthcoming). Most scholars trace the origins of Andean portraiture to the Viceroy Francisco de Toledo, who, in 1572, ordered paintings of the Pre-Hispanic Inka rulers to be made.[3] He then had them sent to King Philip II of Spain in Madrid, where they subsequently burned in the palace fire of 1734. Since there was no tradition of Pre-Hispanic Inka portraiture for the artists to draw on, these were primarily "portraits" of clothing, regalia, and physiognomic types. These aspects of the so-called portraits, together with noble pose and carriage, bore the burden of royal signification. Because at least a few of these "kings" were legendary, colonial portraiture invented them and rendered them historical. For example, although scholars are certain that the founder of the Inka dynasty (Manko Qhápaq) is largely or entirely mythical, many colonial-period members of the Inka elite claimed descent in a direct line from him and possessed portraits of him. Portraits that averred his existence allowed complicated and still poorly understood Andean systems of kinship to be concretized in European terms. Through analogies to the European practice of royal portraiture, these paintings *created* a royal Inka dynasty in the image of European royal lineages and worked to refashion Inka rulers into kings that Europeans could recognize. Of course, the Andean canvases also subvert the genre of portraiture, as imported from Europe, in which paintings were understood to depict actual individuals. More will be said later about the subversive nature of Inka portraits.

Series of royal portraits not only provided models of Inka royalty for their colonial-period descendants, but also argued for a certain, implicitly linear understanding of the past. Hence, these series of Pre-Hispanic portraits complemented efforts by colonial-period chroniclers to write Inka history in a way that conformed to European historical modes of recording. Andean oral histories concerning only partially historical rulers were tailored to fit the familiar pattern of conventional European histories composed as successions of male rulers and their major accomplishments.[4]

Portrait series of rulers lent a visual face to the chronicler's textual descriptions and reinforced Europeanized versions of Andean history in which past events were aligned and affixed to a single male ruler who had followed his father who was a single male ruler, and so on. The Pre-Hispanic Inka rulers, when visually inscribed in this manner and format, are objects of European self-reflection.

While we have no real idea of what Toledo's paintings looked like, we do have other early portrait series, particularly that which illustrated Antonio Herrera's *Historia general de los hechos de los castellanos*, published in 1615. Although some scholars suspect that the Herrera engraving is based on Toledo's portraits, Teresa Gisbert suggests that the model for the Herrera engraving was a painting depicting the Pre-Hispanic Inka rulers and their descendants that was sent to Spain in 1603. This painting was commissioned by Inkas of royal descent in Cuzco and was sent to the court in Spain as evidence of their royal heritage and, therefore, their claim to rights as nobility under Spanish law (primarily to be exempt from tribute obligations). Unfortunately, this painting no longer exists; we do have a sketchy description offered by the *mestizo* author Garcilaso de la Vega, to whom the painting was sent. Garcilaso was living in Spain, received the painting, and passed it (as well as the obligation to present the Inkas' petition at court) to Don Melchor Carlos Inca, the grandson of the last Pre-Hispanic Inka ruler (Wayna Qhápaq), who was also in Spain at the time. Of the image, Garcilaso ([1609] 1966, 625) says,

> for clear proof and demonstration [of their royal ancestry] they included a genealogical tree showing the royal line from Manco Cápac to Huaina Cápac painted on a *vara* and a half of white China silk. The Incas were depicted in their ancient dress, wearing the scarlet fringe on their heads and their ear ornaments in their ears; only their busts were shown.

No doubt influential on later portraits created in Cuzco were the full-body portraits of Pre-Hispanic Inka rulers, painted sometime after 1644, that hung in the Colegio de San Francisco de Borja, the Jesuit school for the sons of native elites in Cuzco. While other early portrait series were

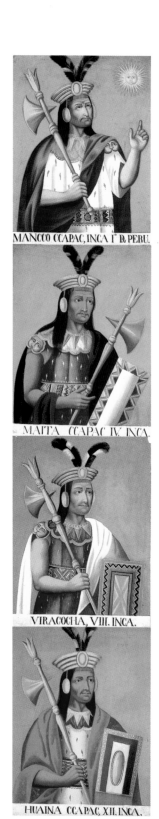
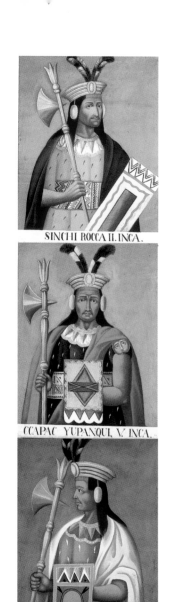
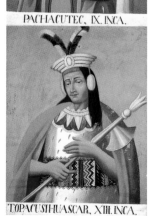

MANCCO CCAPAC, INCA Iº D. PERU.

SINCHI ROCCA II. INCA.

MAITA CCAPAC IV. INCA.

CCAPAC YUPANQUI, V. INCA.

VIRACOCHA, VIII. INCA.

PACHACUTEC, IX. INCA.

HUAINA CCAPAC, XII. INCA.

TOPACUSIHUASCAR, XIII. INCA.

Figure 1 (left to right across spread) 84

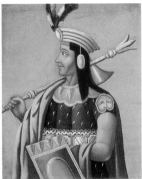

LLOQQUE YUPANQUI, III. INCA.

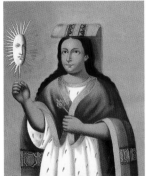

MAMA OCLLO HUACCO L CCOYA D. PER.

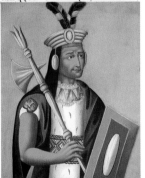

INCA ROCCA, VI. INCA.

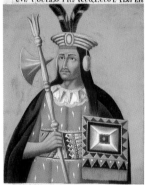

YAHUAR-HUACCAC, VII. INCA.

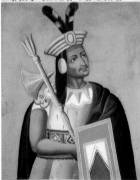

INCA YUPANQUI X. INCA.

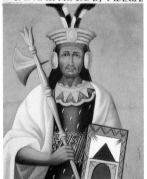

TUPAC YUPANQUI, XI. INCA.

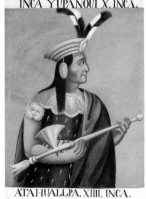

ATAHUALLPA, XIIII. INCA.

D. FRAN.co PIZARRO CONQUIS.or D. PER.u

sent to Spain, these remained in Cuzco throughout the colonial period. It is not insignificant that most portraits commissioned by Inka nobles in the colonial period show the full body like those hanging in the Colegio.

While Toledo's paintings, the painting sent by the descendants of Inka royalty to Garcilaso, the Colegio canvases, and other early colonial-period portrait series have been lost, we have many of their conceptual if not actual descendants in the form of paintings from the seventeenth, eighteenth, and later centuries. Both Spanish authorities and indigenous Inka nobility commissioned paintings of Pre-Hispanic royalty to adorn the homes, schools, hospitals, and religious structures of colonial Peru. In the seventeenth-century Andes, two clear types of Inka portraiture emerged. In one type, members of the Pre-Hispanic dynasty are replaced by Spanish authorities. These dynastic portrait series worked to reinforce the Spanish regime by underscoring the *end* of the Inka dynasty. In the collection of the Denver Art Museum, for example, is a series of sixteen paintings depicting the succession of thirteen Inka rulers from the legendary founding couple, Manko Qhápaq and Mama Ocllo, who are located in the upper left and right, respectively (fig. 1). There is also a sixteenth-century portrait, that of the Spanish conquistador Francisco Pizarro; appearing in the lower right, he literally marks the end to the Inka line. In other, similar paintings, the string of Inka rulers is followed by depictions of the Spanish kings.

The dynastic painting in the Denver collection dates to the nineteenth century, after Peruvian independence. It is a late example of a genre popular in the Andean area throughout the late colonial period and early republic. Most are likely based, at least conceptually, on an engraving made by the Limeño artist Alonso de la Cueva Ponce de León sometime in the first half of the eighteenth century (Gisbert 1980, 128–135). They were most popular in Lima and other centers of Spanish power such as Santiago, Chile, and Potosí, Bolivia. In the engraving and early copies, all members of the dynasty as well as their Spanish "replacements" are pictured in the same composition. In later examples, as the theme became increasingly popular and widespread, individual portraits sometimes occupied distinct canvases, but were meant to be displayed in a group.

86

Often, as in the Denver example, items of Pre-Hispanic costume are clearly imaginary. This is particularly the case with the bowl-shaped headdress, often likened to a flower pot, that was apparently invented by Alonso de la Cueva. It is probably based on his misinterpretation of earlier portraits along with the artist's expectations about what "pagan" costume ought to look like. The Inka headdress was probably confused with Muslim turbans, Muslims (Moors) being the prototype for non-Christians from an early modern Spanish perspective. Spaniards, for example, often described Andean temples as "mosques" even though Islamic and Inka architecture have nearly nothing in common. Likely, Cueva understood the Inka's *llautu*, a plait wrapped around the forehead, as a wrapped turban akin to those worn by some Muslims.

While typically, and not too surprisingly, this genre of painting was commissioned and owned by Hispanics, typically, and not too surprisingly, dynastic portraits commissioned by Inka owners do not follow the same inevitable march to conquest. Descendants of Inka royalty continued to send paintings to Spain as evidence of their heritage throughout the colonial period (Gisbert 1980, 119). In this type of painting, the royal lineage continues from the Pre-Hispanic era into the colonial period in order to demonstrate the clear relationship between the living descendants of rulers and their royal ancestors. Not all images of Pre-Hispanic royalty commissioned by members of the indigenous elite were sent to Spain along with petitions, however. In Inka households, paintings of the ruling lineage averred the heritage of the residents. In these images, too, the line of indigenous kings was most often followed by their colonial descendants. Doña Isabel's series, mentioned at the outset, for example, consisted of eight life-size, full-body portraits including a portrait of her own father, Don Juan Quispe Tito.[5] Similarly, the powerful Chiguan Topa family had twelve portraits of Inka royals in their Cuzco house.[6] The series was apparently either originally commissioned, or at least enhanced, by Don Marcos Chiguan Topa, a dominant political figure in eighteenth-century Cuzco, who is the subject of one of the portraits (fig. 2).[7] Thus, the series included not only Pre-Hispanic rulers, but Don Marcos himself and other colonial-period descendants of Inka royalty, both male and female.

The Chiguan Topa family traced their lineage to the Inka ruler Lloque Yupanki, and so the series that hung in their Cuzco residence probably mapped their royal heritage from that ruler to the time of Don Marcos. Through paintings, colonial Inka nobles intertwined themselves with mytho-historical Inka rulers, and, not coincidentally, did not acknowledge Spanish monarchs. In native hands and homes portraits of Pre-Hispanic rulers and their colonial-period descendants deny the Spanish invasion its purported power to sever the flow of Inka history by dividing Andean eras into disconnected pre- and postconquest periods (Dean 1999, 118).

While colonial-period portraits allege continuity with the past, they also came into being because of the Spanish interruption of Inka practices. Before the Spanish invasion, the Inkas preserved their royal deceased; they did not make likenesses of them. In the Inka tradition, the powerful essences (the animas) of rulers and other important men were housed in sculptures, usually of stone; these were called *wawkis* (*huauques*), meaning "brothers." From what we can glean from vague Spanish accounts, they were likely not anthropomorphic, and they were certainly not portraits in the common sense of the word (Dean, forthcoming). Often the sculptures were powered by royal sheddings—the fingernails and hair of the ruler whom they surrogated. The Inkas, like other Andeans, also took great care to preserve the bodies of their deceased. Both surrogate statues and mummies were revered, kept, dressed, fed, conversed with, and treated as though they were still animate or capable of imminent animation. Both mummies and statues owned

Figure 2

land and had cadres of servants. While it is impossible to say why some cultures develop certain kinds of representations and others not, perhaps there was no Inka tradition of portraiture at least in part because there was no absence to disavow. In other words, because bodies or surrogate bodies were actually kept, no superficial likenesses—such as portraits—were necessary.

Initially Spaniards sought out royal mummies for the treasures in precious metals that they were rumored to possess. The Jesuit chronicler Bérnabe Cobo ([1653] 1979, 132) reports that the eighth ruler, Viracocha Inca,

> left an idol named Inca Amaro, which he designated as his brother and which was much revered by his tribal group. The body of this king was deposited in Jaquijaguana, and having some information and indications of its whereabouts, Gonzalo Pizarro [the brother of conquistador leader Francisco] searched a long time for it in order to get the great treasure that was widely thought to be buried with it; in order to discover it, he burned some Indians, men and women. At last he found it and a large amount of wealth was given to him by the Indians who looked after it. Pizarro had the body burned but the Indians of the Inca's *ayllo* [lineage group] collected the ashes, and with a certain concoction, they put them in a very small earthenware jar along with the idol, which, since it was a stone, was left by Gonzalo Pizarro's men, who paid no attention to it. Later, at the time when Licentiate Polo [Juan Polo de Ondegardo] was in the process of discovering the bodies and idols of the Incas, he got word of the ashes and idol of Viracocha; so the Indians moved it from where it was before, hiding it in many places because, after Gonzalo Pizarro burned it, they held it in higher esteem than before. Finally, so much care was taken in searching that it was found and taken from the possession of the Inca's descendants.

Cobo ([1653] 1979, 162) outlines a similar tragic and brutal narrative with regard to the eleventh ruler, indicating that Spaniards searched for the body because it was believed to have great treasures with it ("and they even resorted to violence many times"), but members of his lineage kept

moving it, and finally, "the Indians wept bitterly when the body was discovered" and taken from them.

These accounts reveal the loyalty indigenous Andeans had to the mummies and statues of the deceased rulers. Only by torture did Spaniards succeed in ascertaining their whereabouts. While the conquistadors initially sought the treasure, Spaniards quickly realized that the mummies (even when in ashes) and statues were dangerous because they still commanded considerable authority—both political and religious. After the Spanish magistrate of Cuzco systematically tracked them down, they were taken to the Spanish capital of Lima—far away from the Inka political and religious center of Cuzco—and buried.

It is possible that colonial-period painted portraits served as surrogates for the confiscated corpses and their brother-statues; painted images of rulers were assembled and displayed in the corridors of colonial homes in a way reminiscent of the gatherings of mummies in the temples and plazas of Pre-Hispanic Cuzco. Certainly, in the European tradition, it is sometimes the case that portraits have "presence"; that is, they are treated as if they were the personage they represent (Freedberg 1989). The Spanish diarist Josephe de Mugaburu (Mugaburu and Mugaburu [1640–1697] 1975) provides numerous examples from his descriptions of ceremonies in seventeenth-century Lima while he was sergeant of the palace guard there. On one occasion in 1666, the portrait of Spanish king Charles II was removed from the council hall in Lima and seated on a throne located outside in the plaza next to the door of the palace; its appearance in the plaza was heralded by musket and artillery fire, flag salutes, and shouts of praise from the crowd. The portrait, serving as a surrogate king, received offerings from indigenous Andean leaders and Spanish colonial dignitaries alike (Mugaburu and Mugaburu [1640–1697] 1975, 105–106). Perhaps Inkas in the colonial period, seeing how painted portraits substituted for absent Spanish rulers, embraced portraiture as a means of keeping their royal ancestors around and present. Perhaps colonial-period portraits of Pre-Hispanic rulers authorized and empowered their descendants in much the same way that possession of the royal mummy once lent considerable authority to its guardian.

While we might suspect that Andeans would embrace this particular aspect of European portraiture, we find no firm evidence. We do know, however, that noble indigenous Andeans themselves enacted their royal ancestry for important celebrations. That is, they became their ancestors when they dressed in Pre-Hispanic garb on certain festive occasions. In the colonial period, the two most important occasions for these enactments were the feast day of Santiago (Saint James), the patron saint of Spain, and the Corpus Christi celebration. For both festivals, Spanish authorities required indigenes to participate. In celebrating Santiago, natives were understood to be declaring their loyalty to Spain; in celebrating the Corpus Christi, they were understood to be declaring their loyalty to the Christian God and Roman Catholicism.[8] We are fortunate to have a series of paintings dating to the final quarter of the seventeenth century that depict Inka nobles participating in the Corpus Christi procession in Cuzco, Peru. Some of the canvases, such as that depicting Cuzco's parish of Santiago (fig. 3), feature descendants of Pre-Hispanic Inka rulers dressed in modified royal Inka regalia of the sort they wore for both Corpus Christi and the feast of Santiago. They wear fine tunics with solar pectorals and

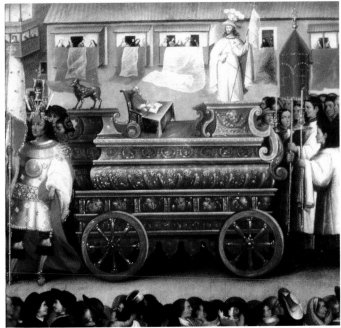

Figure 3

91

headbands featuring the scarlet fringe that was the exclusive mark of the ruler in Pre-Hispanic times. These indigenous costume elements have been modified to suit Spanish tastes and customs. Breeches have been added to the costume, as have lace sleeves; jewels adorn the colonial headdress. As I have discussed in depth elsewhere, these accommodations were made in order to communicate the subject's noble heritage in ways that both Spanish authorities and Andean constituents could readily comprehend (Dean 1999, 97–170). The costumes articulated the subjects' key role as mediators between Spanish authorities and Andean commoners, and so highlighted the role of these important indigenous men, who were called *caciques* in the colonial period.

Paintings of participation in the Corpus Christi festival were complemented by portraits of colonial-period *caciques* in costumes they wore on those occasions. The eighteenth-century portrait of Don Marcos Chiguan Topa, for example, depicts the subject in his role as "royal standard bearer" (*alférez real*), a highly desirable festive role that was held by *caciques* of royal Inka heritage in Cuzco in rotation (fig. 2).[9] He holds the royal Spanish standard in his right hand and, significantly, wears the modified Pre-Hispanic headdress, the sign of indigenous authority by which he earned the right to carry the royal standard as the representative of the royal Inka dynasty in Cuzco. Such colonial-period portraits, then, cannot be understood without reference to the performances they document. The portraits of colonial Inka *caciques* paralleled their performances, in which the *caciques* became transient monarchs in the manner of performed effigies, whose surrogation summoned the specter of long deceased Pre-Hispanic Inka rulers for festive celebrations.

Appearing in costume as a Pre-Hispanic Inka—especially the wearing of the headdress (called *maskapaycha*)—was a public declaration of both legitimate descent from a Pre-Hispanic ruler and, importantly, a colonial political position (that of *cacique*). The Spanish colonial government officially recognized, and exempted from tribute obligations, those members of the Inka elite who were able to show "proofs" (usually by witness testimony) of their legitimate descent from Inka kings. This privileged group was represented in Cuzco by a body of twenty-four electors colloquially

known as the "legitimate Inkas of the *maskapaycha*" ("Ingas lexítimos de la mascapaicha") because only they were allowed to wear the royal headdress in public. Because wearing the *maskapaycha* was evidence of local status and privilege as well as royal heritage, paintings of individuals wearing the *maskapaycha* documented their positions and, in fact, supplemented the "proofs" of nobility. Although Inka women could not wear the *maskapaycha* themselves, they commissioned portraits showing them with the headdress, usually prominently positioned on a table beside them (fig. 4). For a woman, to be shown in close association with the headdress—and usually the subject reaches towards it in a way that draws the viewer's attention to it and suggests her ownership of it—is to make a claim to her legitimate status as a descendant of Pre-Hispanic royalty. While none of the portrayed *ñustas* (princesses) can be identified today, we do know that Doña Antonia Loyola Cusi Tito Atau Yupanqui had among her possessions a painted portrait of an Inka as *alférez real* ("lienzo del retrato del Ynga de Alferes Real de dos baras con su chorchola dorada nueva" [can-

vas of a portrait of the Inka and royal standard bearer measuring two *varas* with its new gilded frame]) and a second painting depicting a *ñusta* ("retrato de la Nusta de dos baras asi mismo con su chorchola dorada nueba" [portrait of the princess measuring two *varas* also with its new gilded frame]).[10] These may well have been portraits of herself and her husband, or, perhaps, her parents.

These portraits are inherently culturally hybrid or composite artworks because they entwine both European and Andean signs and sign-systems.

Figure 4

93

Let us consider the painting of Don Alonso Chiguan Topa that was commissioned by his descendants, probably by the Don Marcos mentioned above (fig. 5). In the portrait, we find a multiply, mixed representation. Not only is an Inka depicted in European media, rendered according to European portrait conventions, but the subject wears a composite costume consisting of an Inka tunic with the signs of indigenous nobility—called *tokapu*—around the hem, armholes, and neck, combined with European breeches. We also have a reference to religious hybridity manifested through the cross in Don Alonso's hand and the sun on his chest; the sun—called Inti—was the patron deity of the Pre-Hispanic Inka state. The sun pectoral on his chest dims in contrast to the cross, which emanates light. According to the legend on the portrait, Don Alonso, a descendant of a Pre-Hispanic ruler, was the first Inka to be baptized following the Spanish invasion. He is shown with the coat of arms granted by the Spanish king to those descendants of Inka royalty who remained loyal to the Spaniards during an Inka rebellion early in the colonial period.[11]

Figure 5

The portrait was made by his descendants in order to establish not only their royal ancestry, but their devout Catholicism and the history of their allegiance to the Spanish government.

The painting of Don Alonso met its match many decades later in the painting of an anonymous Inka *ñusta* now in the collection of the Denver Art Museum (fig. 6, frontispiece this chapter). Probably painted early in the nineteenth century, the painting shows a woman dressed in Pre-Hispanic Inka garb. The inscription claims that this princess was the first

Christian woman in the Andes. When an Inka man attempted to violate her vow of chastity, she fought and beheaded him. Through this action, she replicates a feat credited to the legendary first Inka queen, who conquered Cuzco by decapitating an enemy, an action that paved the way for the foundation of the Inka empire. This portrait, then, casts its subject at the beginning of a new cycle of time in which the Inka dynasty is reborn as Christian. It also borrows heavily from Christian iconography—specifically that of the biblical Judith, who saved the Jewish nation from foreign domination by beheading an Assyrian general named Holofernes. Prints and paintings of Judith with the head of Holofernes circulated widely in colonial Peru and so probably furnished inspiration for the composition of this painting, which was undoubtedly commissioned by the descendants of this noble Inka *ñusta* just as the Chiguan Topa family commis-

Figure 6

95

sioned the posthumous portrait of Don Alonso. We have no way of knowing whether either individual actually ever existed and whether they performed the acts attributed to them. We do know that it was important to later generations that their existence be documented through portraiture in much the same way that the existence of Pre-Hispanic rulers was averred through painted images.

Considered in isolation, the portraits of both Don Alonso and the anonymous *ñusta* could be read as records of self-subordination that, by extension, refer to the religious conversion of all Inka peoples. Even though such portraits appear to show us self-possessed individuals, we must wonder whether colonized peoples were ultimately enfeebled by the cultural hybridity displayed in the portraits they commissioned and hung on the walls of their homes. They adopted (appropriated?) portraiture as a means of historicizing Pre-Hispanic and even early colonial-period individuals. They did this because portraits meant something in European terms, and it was to Spanish overlords that they were appealing. Thus, colonial-period portraiture implicitly and necessarily characterizes its subjects as subjected. However, it also raises a question that vexes anyone studying religious conversion in colonial societies. To wit, when is religious conversion a matter of faith and when is it a matter of capitulation? Christianity was a crucial aspect of colonial-period Inka identity, and we know from available records that many Inkas were devout Roman Catholics. Consequently, it is quite simply inappropriate for modern scholars to read all signs of Inka Catholicism as evidence of capitulation, compliance, and passive acquiescence to colonial authority.

Such paintings clearly serve indigenous Andean agendas even though they are just as clearly expressed in accordance with European modes of representation. They compel us to wonder how long colonial portraiture remained a European genre and how long oil painting on canvas remained a European medium. It seems obvious that, by the end of the sixteenth century (seventy years after the Spanish invasion), Andeans did not recognize portraiture as an alien form of expression. This does not mean, however, that in the colonial portraits Inkas were seeing themselves solely through European eyes. The subject is characterized as someone of

importance within colonial society, and her or his importance depends as much upon indigenous Andean cues (costume and regalia) as it does upon European ones. Hence, the portrayed subject is both ruler and ruled. This critical mediative position is established precisely through the composite or hybrid nature of the artwork.

Elsewhere, I have used the term "renewal" to characterize the colonial process of investing traditional forms derived from one culture with new, transcultured meanings (Dean 1996).[12] Andeans renewed European portraiture by figuring the subject—whether *cacique* or *ñusta*—ambivalently and paradoxically in colonial culture as a subjected ruler. Colonial Inka leaders were compelled, both by subtle and by not-so-subtle acculturative pressures, to Hispanicize. Yet, as Homi Bhabha (1984) has argued, although colonized elites are often induced to imitate the colonizer, they can never *be* the colonizer. Thus, hybridity is the inevitable and ultimate product of colonization. Expressions of Pre-Hispanic indigeneity were not an option for Andeans once the Spanish colonial presence was established. Any search for an Inka untouched by colonization traps Inka peoples in an ahistorical conundrum and ignores the colonial transformation of Inka lives. Hence, we must conclude that colonial portraiture commissioned by members of the Inka elite and featuring Inka subjects *is* Inka despite all its hybridity; as is the case with Inka costume, the portraits are simply (or, rather, not so simply) not *Pre-Hispanic* Inka (Dean 1999, 162).

Inka *caciques* and *ñustas* appear to have recognized the ambivalence inherent in their mediative positions—the necessity of being both native nobility (therefore pedigreed to retain political positions) and Christian (therefore "suitable" for Spanish service). On the one hand, their indigenous ancestry gave them status within Cuzco's political hierarchy; on the other hand, political power was explicitly granted through the Spanish system. Certainly, Inka leaders recognized that it was precisely their Pre-Hispanic heritage that conferred on them the status which in turn enabled them to administer local populations for the Spanish colonial government. It was in their interest, therefore, to identify as members of the indigenous nobility and to render the signs of Andean nobility in a manner easily apprehended by the Spaniards (Dean 1999, 160–170). That their

cultural mediativity does not necessarily constitute compliance with colonial authority can be seen through comparison with the many colonial-period images, usually painted by artists of Spanish heritage, in which Inkas are characterized as the passive recipients of Catholic grace. In a painting of the three magi from the Jesuit mission in Juli, Peru, for example, one of the kings is depicted as an Inka ruler (fig. 7). As is typical in this type of painting the Inka is reverent and receptive. (The African king is as well, but that's the subject of a different study.) This anonymous "Inka" presents a very different figure from both the staunchly erect Don Alonso Chiguan Topa, who holds aloft the cross he has taken rather than received, and the fierce Christian *ñusta,* who has actively defended herself and her new religion.

Both the princess and Don Alonso are shown as individuals who have made choices. They have taken Christianity rather than having it given to them. For us, they represent the new Inka couple who generated a new cycle of Inka time. They span the gap between Pre-Hispanic and colonial, between non-Christian and Christian eras. In his portrait Don Alonso's body literally bridges the distance between the solar disk that recalls the Inti of his ancestors and the luminous cross of his Christian descendants.

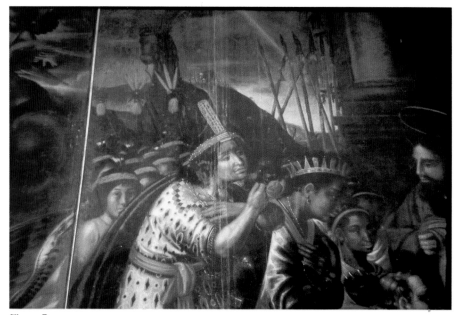

Figure 7

Although it has been asserted that for the colonial Inka elites to utilize the significatory system of the colonial regime, as they did in portraits of themselves, was to self-subjugate, to characterize portraiture as "European" in contexts where it clearly serves Andean ends is to understand the genre from a solely European perspective.

Whether intentional or not, the appropriation of the colonizer's visual rhetoric by Inka *caciques* was essentially a subversive strategy, for the adaptation of European portraiture to the demands and requirements of the place and society into which it had been appropriated amounted to a subtle rejection of the political power of unmodified European visual discourses. Simon During (1987) has explored the problem of how the colonized might use the colonizer's language to "speak" themselves—that is, to articulate native identity—without, in the end, being spoken by it, without having *it* define *them*. His thought-provoking essay queries whether human beings use cultural tools—such as written language, or, for our purposes, visual imagery—to express themselves, or whether the tools inevitably shape those who use them. Although in our case the tools—European modes of representation—used by the midcolonial Inkas defined the perimeters of what they might create and how they created, in the end the tools did not determine *what* the Inkas created and certainly did not determine the colonial Inkas themselves (Dean 1999, 165–166).

It is interesting to note that in all the colonial-period wills, inventories, contracts, and other documents I have examined while researching postconquest Inka visual culture for the past decade, not once are portraits of Inkas treated as oddities, as hybrid adaptations by colonized peoples. Not only did the Andean subjects of portraiture and their peers make no note of the heterogeneity of their paintings because to them it was unremarkable, but throughout colonial Spanish America, people willingly (if not self-consciously) mixed items of diverse origins yet found such mixtures acceptable, if not also commonplace (Dean and Leibsohn 2003). Rather, and significantly, it was Europeans who eventually fretted over difference and found the material objects of their own expansion and colonization collectible precisely because of their mixed nature and the acts that gave rise to that mixing. The oil paintings of Pre-Hispanic

Inka rulers were not problematic to the people of colonial Peru until the late eighteenth century, when, in the wake of a series of rebellions, the Spanish colonial government prohibited the display of portraits of Inka royalty in an order that was issued in 1782 and ratified in 1795. It did so because the idea of a revitalized Inka monarchy, given material form by these portraits, inspired those who sought to overthrow colonial rule. Not only were images of Pre-Hispanic rulers prohibited, but so too were portraits of their colonial descendants who were accustomed to adorning themselves in royal Inka regalia on special occasions. The costumes and accoutrements that colonial-period Inka elites wore to evoke their royal ancestry, especially headdresses, were also perceived as a threat and so outlawed as well. What made the regalia and portraits a "problem" to the Spanish colonizers was not in itself their visual hybridity; what made them problematic was what they meant to a portion of their eighteenth-century audience. Because they evoked a past that presented an alternative to the colonial present, they were quite possibly subversive. Signs of difference that had gone unremarked until the rebellions of the late eighteenth century then became intolerable. Thus it was the historically conditional menace of difference that caused the mix to be both noticed and feared. When we recognize cultural mixing in portraits where indigenous people did not, then, we necessarily inherit and pass on the legacy of European colonization, which manifests itself as a need to find difference, to hold it out and hold it special, if not also suspicious (Dean and Leibsohn 2003).

European visual lexicons can and did communicate very non-European things when "spoken" by Andeans. Representational realism, in the European manner, when used by Inka *caciques* in their costumes, portraits of themselves, and other midcolonial artifacts, did not impart only European perceptions of the world. The genre may have been partially non-Andean, but the order, structure, and message were not. To return to our original question, can we now reconcile the acculturated and compliant Inkas who adopted portraiture as a way to "fit in" with the incipient revolutionaries who utilized portraits to keep alive memories of a powerful, independent, indigenous-ruled Peru (Majluf 1993, 242; Damian 1998)? The answer, it seems to me, is clear. Our portrayed subjects are

necessarily both acculturated and revolutionary, for they were both leaders and subjects. The canvases, then, whether of real, historical individuals or legendary personages whose existence is merely asserted, might be best characterized as portraits of paradoxes.

Notes

1 Funding for research was provided by grants from the senate committee on research and the Division of the Arts committee on research at the University of California, Santa Cruz.

2 A list of Doña Isabel's possessions can be found in her two wills, which contain an inventory of her house in Cuzco (ADC, Lorenzo Messa Anduesa, leg. 195, 1662, fols. 1354r–1378r; ADC, Lorenzo Messa Anduesa, leg. 199, 1665, fols. 1159r–1176v).

3 See Gisbert (1980, 117–146) for the most comprehensive study of the colonial-period portraits of Pre-Hispanic Inka rulers.

4 Modern scholarship has raised some serious questions about the historical accuracy of colonial-period accounts of Inka history, including the possibility that Andean rulership was dual. See, in particular, Duviols 1979 and Zuidema 1964 and 1990.

5 See ADC, Lorenzo Messa Andueza, leg. 195, 1662, fols. 1354r–1378r; ADC, Lorenzo Messa Andueza, leg. 199, 1665, fols. 1159r–1176v.

6 The early nineteenth-century inventory of the belongings of the deceased Doña Martina Chihuantupa de la Paz refers to twelve portraits of "Inkas" from the Chihuantopa (Chiguan Topa) family that had been hanging in the hall of her residence ("dose retratos de los Yngas de la familia de Chihuantopa que estuvieron en el corredor") (ADC, Mariano Meléndez Páez, leg. 181, 1812–1813, fols. 529r–531r).

7 Some of these images of the Chiguan Topa family are now in the Museo Arqueológico in Cuzco, Peru. Doña Martina, see note 5 above, may well be one of the anonymous *ñustas* in the Museo's collection.

8 See Dean (1999, 7–45) for a detailed discussion of the importance of the festival of Corpus Christi as the celebration of a generalized triumph over non-Catholics.

9 For further information about the Inka *alférez real* in Cuzco, see Dean (1999, 100).

10 See ADC, Juan de Dios Quintanilla, leg. 231, 1755–1762, fols. 260r–267v.

11 The arms were granted to Cristóbal Paullu, the son of ruler Wayna Qhápaq, and his heirs following the rebellion led by Manko II.

12 Damian (1998) also uses the term renewal in reference to Inka noble portraits of the colonial period.

Bibliography

Archival Sources

ADC Archivo Departamental de Cusco

Published Sources

Bhabha, Homi K. 1984. "Of Mimicry and Man: The Ambivalence of Colonial Discourse." *October* 28:125–133.

Cobo, Bérnabe. [1653] 1979. *History of the Inca Empire: An Account of the Indians' Customs and Their Origins together with a Treatise on Inca Legends, History, and Social Institutions*, ed. and trans. Roland Hamilton. Austin: University of Texas Press.

Cummins, Thomas B. F. 1991. "We Are the Other: Peruvian Portraits of Colonial *Kurakakuna*." In *Transatlantic Encounters: Europeans and Andeans in the Sixteenth Century*, ed. Kenneth J. Andrien and Rolena Adorno, 203–270. Berkeley: University of California Press.

Damian, Carol. 1998. "Inka Noble Portraits: The Art of Renewal." *Secolas Annals* 29 (March): 13–20.

Dean, Carolyn. 1996. "The Renewal of Old World Images and the Creation of Colonial Peruvian Visual Culture." In *Converging Cultures: Art and Identity in Spanish America*, ed. Diana Fane, 171–182. New York: Brooklyn Museum and Harry N. Abrams, Inc.

_____. 1999. *Inka Bodies and the Body of Christ: Corpus Christi in Colonial Cuzco, Peru*. Durham: Duke University Press.

_____. (forthcoming). "Metonymy in Inca Art." In *Presence and Images: Essays on the 'Presence' of the Prototype within the Image*, ed. Rupert Shepherd and Robert Maniura. Hants: Ashgate Publishing.

Dean, Carolyn, and Dana Leibsohn. 2003. "Hybridity and Its Discontents: Considering Visual Culture in Colonial Spanish America." *Colonial Latin American Review* 12(1): 5–35.

During, Simon. 1987. "Postmodernism or Post-colonialism Today." *Textual Practice* 1, no. 1:32–47.

Duviols, Pierre. 1979. "La dinastía de los incas: Monarquía o diarquía? Argumentos heurísticos a favor de una tésis estructuralista." *Journal de la Société des Américanistes* 66:67–83.

Freedberg, David. 1989. *The Power of Images: Studies in the History and Theory of Response*. Chicago and London: University of Chicago Press.

Garcilaso de la Vega, "El Inca" [Gómez Suárez de Figueroa]. [1609] 1966. *Royal Commentaries of the Incas and General History of Peru*, part one, ed. Harold V. Livermore. Austin and London: University of Texas Press.

Gisbert, Teresa. 1980. *Iconografía y mitos indígenas en el arte*. La Paz: Talleres-Escuela de Artes Gráficas de Colegio "Don Bosco."

Guido, Angel. 1941. *Redescubrimiento de América en el arte*. Rosario: Universidad del Litoral.

Majluf, Natalia. 1993. Reseña de *Transatlantic Encounters: Europeans and Andeans in the Sixteenth Century*. *Revista andina* 11, no. 1:241–243.

Mugaburu, Josephe de, and Francisco de Mugaburu. [1640–1697] 1975. *Chronicle of Colonial Lima: The Diary of Josephe and Francisco Mugaburu, 1640–1679*, trans. and ed. Robert Ryal Miller Norman: University of Oklahoma Press.

Rowe, John Howland. 1951. "Colonial Portraits of Inca Nobles." In *The Civilization of Ancient America*, selected papers of the XXIX International Congress of Americanists, ed. Sol Tax, 258–268. Chicago: University of Chicago Press.

————. 1954. "El movimiento nacional Inca del siglo XVIII." *Revista Universitaria* (Cusco) 7:17–47.

Zuidema, R. Tom. 1964. *The Ceque System of Cuzco: The Social Organization of the Empire of the Inca*. Leiden: E. J. Brill.

————. 1990. *Inca Civilization in Cuzco*. Austin: University of Texas Press.

Figures

Frontispiece Detail of figure 15.

Figure 1 Cristóbal de Villalpando, *The Transfiguration*, 1683, oil on canvas. Cathedral of Puebla, Mexico.

Figure 2 Cristóbal de Villalpando, *St. Peter,* oil on canvas. Museo de Arte, Querétaro, Mexico.

Figure 3 Cristóbal de Villalpando, *The Holy Family,* oil on canvas. Cathedral of Puebla, Mexico.

Figure 4 Cristóbal de Villalpando, *The Lactation of St. Dominic,* oil on canvas. Church of Santo Domingo, Mexico City.

Figure 5 Cristóbal de Villalpando, *Triumph of the Eucharist*, 1686, oil on canvas. Sacristy, Mexico City Cathedral.

Figure 6 Cristóbal de Villalpando, *Glorification of the Virgin,* 1688-89, fresco. Cupola, Cathedral of Puebla, Mexico.

Figure 7 Cristóbal de Villalpando, *The Confession of Saint Francis,* 1691, oil on canvas. Colonial Museum, Antigua, Guatemala.

Figure 8 Cristóbal de Villalpando, *The Holy Souls with St. Michael and St. Theresa*, 1708. Church of Santiago de Tuxpan, Michoacán, Mexico.

Figure 9 Cristóbal de Villalpando, *Woman of the Apocalypse* (detail, lower left), 1685-86, oil on canvas. Sacristy, Mexico City Cathedral.

Figure 10 Cristóbal de Villalpando, *Decapitation of St. Eulalia,* oil on canvas. Museum of the Basílica of Guadalupe, Mexico City.

Figure 11 Baltazar de Echave Orio, *St. Apronius,* 1607, oil on canvas. Museo Nacional de Arte, Mexico City.

Figure 12 Cristóbal de Villalpando, *Ecce Homo,* oil on canvas. Church of San Felipe Neri, La Profesa, Mexico City

Figure 13 Baltazar de Echave Rioja, *Martyrdom of St. Peter Arbúes,* oil on canvas. Museo Nacional de Arte, Mexico City.

Figure 14 Luis Juárez, *Holy Family,* oil on canvas. University of Zacatecas, Zacatecas, Mexico.

Figure 15 Cristóbal de Villalpando, *Joseph Claims Benjamin as His Slave,* 1700-14, oil on canvas. Denver Art Museum, Collection of Jan and Frederick R. Mayer.

Figure 16 Cristóbal de Villalpando, *Saints Justus and Pastor,* oil on canvas. Institute of Visual Arts, Puebla.

Figure 17 José Juárez, *Saints Justus and Pastor,* oil on canvas. Museo Nacional de Arte, Mexico City.

Figure 18 José Juárez, *Appearance of the Virgin and Child to St. Francis,* oil on canvas. Museo Nacional de Arte, Mexico City.

Figure 19 Cristóbal de Villalpando, *Martyrdom of St. Lawrence,* ca. 1690, oil on canvas. Hermitage of San Lorenzo, Tlalpujahua, Michoacán, Mexico.

Figure 20 Engraving by Cornelius Cort based on Titian, *Martyrdom of St. Lawrence,* 1571.

Figure 21 José Juárez, *Martyrdom of St. Lawrence,* oil on canvas. Museo Nacional de Arte, Mexico City.

Figure 22 Miguel Cabrera, *Virgin of the Apocalypse,* oil on canvas. Guadalupe College of the Propagation of the Faith, Zacatecas, Mexico.

Figure 23 Cristóbal de Villalpando, *Virgin of the Apocalypse,* 1685-86. Sacristy, Mexico City Cathedral.

The Painter Cristóbal de Villalpando:
His Life and Legacy

Juana Gutiérrez Haces
Research Fellow, Instituto de Investigaciones Estéticas,
Universidad Nacional Autónoma de México

During the second half of the seventeenth century, New Spain, one of the wealthiest colonies in the Spanish Empire, was justly proud of its lands, riches, and creative endeavors. The leading writers of the time expressed this sense of pride, and, when speaking of local talent, included painters. Thus, in 1683, the illustrious Mexican scholar Carlos de Sigüenza y Góngora, in *Triunfo parténico,* one of the greatest tributes ever made to art created in New Spain, described the temporary outdoor altars and altar screens that were erected throughout Mexico City for religious festivities in honor of the Immaculate Virgin:

> Magnificent paintings were found everywhere, even in the empty spaces of ceilings that damasks had left uncovered; these brilliantly colored works were made not only by foreign artists, but also by our Mexican countrymen, who deserve to be equally valued: in fact, they are outstanding, not only in regard to European painters but also when compared to artists such as Zeuxis, Apelles, Pharrahasius, and Timantes.[1]

In other words, Sigüenza's enthusiasm led him to claim that local painters equaled foreigners and even the mythical painters of classical antiquity. In that same book, Sigüenza evaluated the most famous painters of New Spain, most of whom had died by then, but were probably included because their works were still considered of sufficient quality to dignify those street altars that expressed love and veneration for the Virgin.

Seventeenth-century Mexicans valued New Spain's art not only because they were well aware of their own legacy, but also because they knew they had a glorious present. During the second half of the century, New Spain filled its cathedrals, palaces, monasteries, and private man-

sions with the greatest paintings ever produced in the New World. Cristóbal de Villalpando greatly contributed to this florescence.

There is little information about his early years, and though his exact date of birth is unknown, a date around 1649 can be extrapolated from the first documentary data, his wedding announcements, published in May 1669 although he actually married María de Mendoza ten years later. The couple was married in the church of Nuestra Señora de la Limpia Concepción, better known as Nuestra Señora del Hospital de Jesús, which belonged to the marquises del Valle, the heirs of Hernán Cortés. Documents also attest that Villalpando was born in Mexico City, the legitimate son of Juan de Villalpando and Ana de los Reyes. His wife was the daughter of Diego de Mendoza, probably a painter who later settled in Puebla.

We have found baptismal certificates for his children as well as some of their death certificates, dated in later years.[2] The documents show that several painters were godfathers to Villalpando's children: Pedro Ramírez to his son Félix in 1672; Baltasar de Echave Rioja to his daughter Ana Manuela in 1677 and again in 1680 to his son Carlos Solano; Nicolás Rodríguez Juárez in 1690 to his son Cristóbal Francisco; and later a certain Francisco de León, probably the painter from Guadalajara, to yet another child. Given the serious commitment entailed in being a Catholic godfather at the time, Villalpando must have had strong ties with these artists, to choose them for such a solemn responsibility.

Relationships among artists in workshops were similar to family bonds, and the religious ties that Villalpando established with these older painters suggest that he had probably been an apprentice in their workshops—specifically those headed by Pedro Ramírez (1638–1679)[3] and Baltasar de Echave Rioja (1632–1682). Both Ramírez and Echave Rioja worked in Mexico City and Puebla, cities where Villalpando produced paintings in his youth and early maturity. If, in fact, these two painters were his mentors, they may have helped him get his earliest commissions, such as his first independent work: the altar screen of the Huaquechula monastery (Puebla), signed and dated in 1675. Unfortunately, this work has been so poorly restored that it is difficult to judge his development as an artist.

In 1675, Villalpando was about twenty-six years old—very young for a painter in New Spain to have his own workshop and to receive significant commissions. Again, if Baltasar de Echave Rioja—who happened to be working at that time in the sacristy of the Cathedral of Puebla—was his mentor, he might very well have delegated the painting of the altar screen to one of his most talented assistants. Echave died in 1682, and Villalpando, having firmly established his reputation in this part of the country, was able to get important commissions such as *The Transfigura-*

Figure 1

tion, a monumental painting (8.65m x 5.50m) for the Cathedral of Puebla, signed in 1683 (fig. 1). This painting is an accurate representation of the religious and personal interests of the well-known bishop Manuel Fernández de Santa Cruz, who—under the pseudonym of Sor Filotea de la Cruz—would respond to Sor Juana Inés de la Cruz's *Carta atenagórica.* The complex reading of this painting reveals that even early in his career, Villalpando had the wisdom and ability to capture the concepts of his patrons.[4]

It is evident that, even at the time he did the altar screen of Huaquechula, Villalpando was familiar with Rubens's engravings, though perhaps this influence came to him via his mentor, since Echave Rioja's last work for the Cathedral of Puebla was based on an engraving by the Flemish master. In fact, the influence of Rubens had permeated New Spain for some years, but it reached its most brilliant interpretation in the hands of Villalpando, who, after improving his skills, continued to copy the Flemish master. His famous *Series of the Apostolate* reveals his reliance on Rubens (fig. 2). Colors, light, and form in *The Transfiguration* further demonstrate Villalpando's complete assimilation and domination of the Flemish master's technique.

Like the whole Spanish kingdom, New Spain followed the models set by Italian, French, and Spanish art, but found its greatest inspiration in the art produced in the Flemish workshops. Copying was a fact of life in artists' workshops, and it explains the ever-present Venetian-style hues and Rubensesque themes and compositions, which were ideal for the cathedrals in seventeenth-century New Spain. These influences not only nurtured American painting but also were assimilated to such an extent as to evolve into a local tradition, a phenomenon similar to eclecticism, in which the inherited

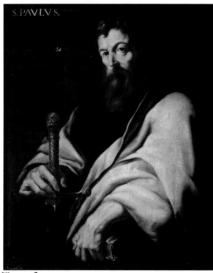

Figure 2

110

components regroup in such a way as to become unrecognizable. This eclecticism established entirely new formal and iconographic relationships, and could be considered one of the main characteristics of New Spain's baroque painting. Results are so innovative that traces of Flemish, Venetian, or Sevillian painting seem to vanish, although a closer look reveals that artists, when copying the great masters, were able to transform those influences to the point of appropriating them.

Villalpando's *The Transfiguration* shows that certain human figures are very similar to those by the school of Rubens, and their transformations and dynamism could be attributed to inspiration from the Flemish artist's workshop. But at the same time, this monumental painting and those painted in the sacristy of the Cathedral of Mexico are examples of a total assimilation of Rubens's style, not because the compositions are similar, but because Villalpando was able to incorporate the dynamism and luminous color of the Flemish master. Villalpando's ability to create fresh interpretations of the human figure, also inherited from Rubens, is apparent in later works such as *The Holy Family* (fig. 3), *The Virgin of Saint Theresa's Veiling,* and *The Assumption of the Virgin,* as well as in the personified virtues and their armies in *The Lactation of Saint Dominic,* which created an American Rubensism, something that not even Rubens could have predicted (fig. 4).

With such splendid results in the Cathedral of Puebla, Villalpando's fame

Figure 3

was firmly established and he was commissioned to work on the most important projects of the viceroyalty. He was the favorite artist of powerful orders such as the Dominicans and Jesuits, as well as of the cathedral chapter houses. The aristocratic families of New Spain ordered devotional paintings and major works from him for cathedrals and parish churches. If the title "court painter" had been used in New Spain, Villalpando would have been the most appropriate artist to fill this role and would have done so with absolute dignity, especially in view of the patronage granted to him by the chapter house of the Metropolitan Cathedral of Mexico.

The following works attest to this status and to his development as a painter. The canvas *The Lactation of Saint Dominic* (3.61 m x 4.81 m) was painted for the Dominicans in Mexico City. It would seem that Villalpando was the painter mentioned in documents related to the *Saint Margaret* altar screen (only the arch survives) dedicated in 1684 for the chapel of Saint Joseph in the cathedral of Mexico, as a tribute to the devotion of the Countess of Peñalva. Also in 1684, he painted one of his masterworks,

Figure 4

112

The Church Militant and Triumphant (7.1 m x 7.51 m), his first canvas mural of the series in the sacristy of the Cathedral of Mexico. In *The Triumph of the Eucharist* (8.99 m x 7.66 m), painted in 1686 for the sacristy series, Villalpando deftly combined elements from two of Rubens's engravings and from an engraving by Martin de Vos with the same subject matter (fig. 5). Flemish influences are also seen in *The Woman of the Apocalypse* (8.99 m x 7.66 m; fig. 23) and in *The Appearance of Saint Michael* (9.29 m x 7.65 m), both for the cathedral.

Figure 5

Juan Correa, Villalpando's contemporary, finished the paintings in the sacristy of the Cathedral of Mexico between 1689 and 1691; he painted *The Assumption* and *Jesus Entering Jerusalem*. The fact that Villalpando did not complete these paintings suggests that he might have had other interests. In 1688, he had promoted himself as a candidate to do the paintings for the Altar of the Kings, the most important altar in Mexico's cathedral not only because it commemorates the power of the king, but because it symbolizes the bond between the Church and the Spanish Crown via the

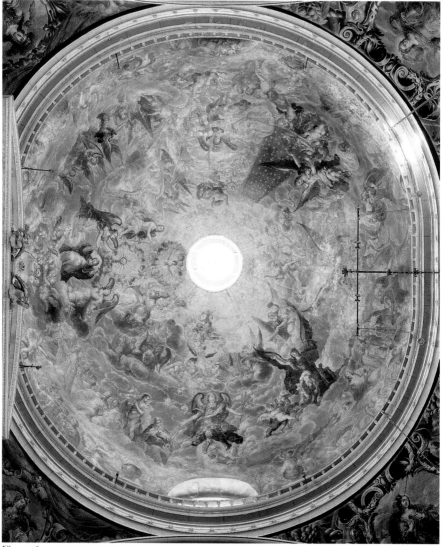

Figure 6

Royal Council of the Indies. In contrast to the sacristy paintings, these would be public and located on the main wall of the cathedral.

Brimming with self-confidence, Villalpando announced his candidacy: "In view of the fact that the painting of the altar piece requires the most demanding endeavor of any commission in New Spain, care must be taken to select a great master." Obviously, he considered himself the best painter in New Spain. But, since the altarpiece was not begun at once, Villalpando left Mexico City to return to Puebla to work on another of the most ambitious projects in the realm, the cupola of the Cathedral of Puebla (1688–1689; fig. 6). In spite of their popularity during the baroque period, very few cupolas in Spanish America were painted. Villalpando's success in the project lies not only in the pictorial qualities, but also in the shadings, with light defining the space occupied by each figure.

Years later, he would paint another *Triumph of the Church* in the sacristy of the Cathedral of Guadalajara (7 m x 5 m), using new elements to create a synthesis of the first work with added meanings. Villalpando also painted magnificent works throughout the realm: the cycle of the *Life of Saint Francis* for the Franciscan convent in Antigua, Guatemala in 1691 (fig. 7); closer to home, *The Holy Souls with Saint Michael and Saint Theresa*, for the church of Santiago de Tuxpan, in Michoacán (7.25m x 5.25m), commissioned by the Count of Miravalle in 1708 (fig. 8); and two years later, the series on the *Life of Saint Ignatius* for the Tepotzotlán monastery, an outstanding piece for its brilliant execution and monumental size. Smaller masterpieces include the paintings for the octagonal walls in the cathedral of Puebla, the altarpiece dedicated to *Saint Rose of Lima* in the Cathedral of Mexico, and the painting dedicated to the *Sweet Name of Mary*, probably for the convent of Saint Bernard in Mexico City (1.83 m x 2.91 m). These and other works assured his preeminence among artists. Villalpando was also a famous sculptor, but we have only documentary references, for his work in this field has not been identified.

An important member of his community, Villalpando held various posts. We can assume that he savored the opportunities offered as he accepted many of them, and that he was a man of means as he dutifully paid the taxes imposed on those holding such posts. In 1686, by order of

Figure 7

Figure 8

116

the outgoing Viceroy Tomás Antonio de Cerda y Aragón, Marquis of La Laguna, Villalpando was named supervisor of the guild of painters and gilders. Documents show that since 1681 the guild's rules had been regularly sent to the Viceroy for his approval and that, according to the rules, the members of the guild would hold elections for the posts of supervisor and examiner; however, Villalpando was on several occasions appointed by the viceroy himself in violation of the guild rules. Thus, Villalpando was responsible for supervising the work of other painters and for the high standards of performance required by the guild—even though it seems that Villalpando himself had not been examined, since the guilds were practically inactive when he was a young painter. The post was, no doubt, a tribute to the fame he had achieved through his paintings for the sacristy of the Cathedral of Mexico. He continued to hold this post, renewed at first by the new viceroy, Melchor Portocarrero Lasso de la Vega, Count of Monclova, and later by elections held by the guild, confirming that he was held in high esteem by his peers as well as by the authorities.

In addition to these guild positions, he belonged to the group of artists who met at the church of Saint John of Penitence, a fact that suggests that he was a member of religious/academic as well as professional/civic guilds. He was also appointed a military lieutenant (1692) and later captain. In order to protect the city from potential uprisings and disturbances, the municipal government ordered that some guild associations form the squadrons of infantry and cavalry that made up the city's troops. The purpose of these forces was defense against pirate attacks—a constant threat along the coasts of New Spain—as no formal army existed at the time other than a small cadre assigned to the service of the viceroy. Not until the eighteenth century would the Regiments of America be formed, composed mainly of foreign mercenaries and local draftees. The guild militias were probably involved in such actions as the uprising of June 8, 1692, whose damage can be seen in Villalpando's painting *View of the Plaza Mayor,* where the reconstruction after the fires at the Palace of the Viceroys has just begun, and the Cathedral of Mexico remains unfinished. The elaborate clothing of the archangels painted by Villalpando gives an idea of the garments used by the guild militias (fig. 9).

Figure 9

Villalpando's private life changed when his first wife died in 1699, and he probably married Gertrudis Cano before 1707, as he had several of their children baptized in later years. His last signed work is dated in 1713. Dedicated to the first Franciscan monastery, the canvas depicts Saint Francis transformed by a vision of the Virgin and Child. This painting shows no decline in Villalpando's artistic ability, in spite of the fact that his workshop was large in later years, sometimes producing uneven results.

Cristóbal de Villalpando died on August 20, 1714 at the age of sixty-five and was buried in the church of Saint Augustine. His unquestionable artistic maturity is explicable only as the result of a long tradition, fully assimilated and bearing its best fruit. And that, precisely, would be another characteristic of the Mexican baroque: the awareness of belonging to a respected tradition, which was followed while at the same time being expanded via innovation. If we define tradition as the transmission from one generation to the next of carefully preserved ideas that are integrated into everyday life until they become part of an identity, we then can recognize that in New Spain such a pictorial tradition existed and was handed down from painter to painter, from master to pupil, and from workshop to workshop. The paintings of Cristóbal de Villalpando are a perfect example of what he inherited from tradition as well as a legacy to future generations.

One must stress that while the painters of New Spain assimilated outside influences, they also created a style of their own, probably as a result of a natural eclecticism. The closed circle of guilds, no doubt, promoted the creation of stylistic languages common to all, though these

118

traditions were interpreted in original ways by each workshop, as artists from several generations of the same family dominated many. These dynasties left a profound imprint on all with whom they came into contact. The Echaves, the Juárezes, the Ramírezes, and other families of painters set models to be followed. In contrast to foreign traditions, this style evolved with elements of local pride, very much in harmony with the boastful statements of Sigüenza y Góngora quoted earlier. Villalpando himself shared this sense of pride with Sigüenza and with Sor Juana, whom he probably met at the court of the Viceroy Antonio Sebastián de Toledo, Marquis of Mancera; and one can add that to all of them, this sense of pride had been a sort of generating force behind their work.

Several paintings support this thesis, among others *Saint Eulalia*, both the one in which her breasts are burned and the one in which she is decapitated (fig. 10). They show the strong influence of Baltazar Echave

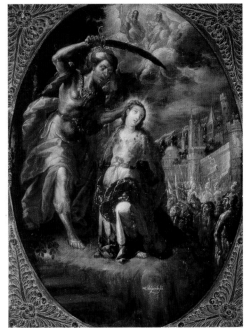

Figure 10

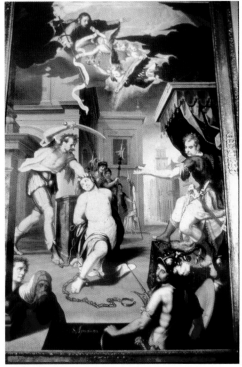

Figure 11

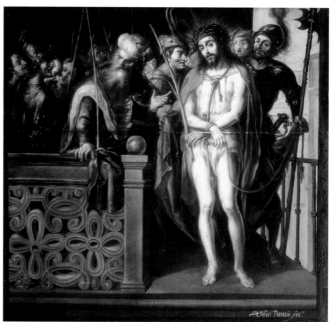

Figure 12

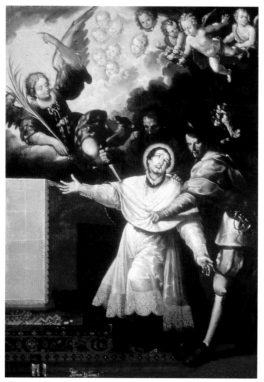

Figure 13

120

Orio (1548–1620), not only because, in the first work, the posture of the saint is similar to those in Echave's *Saint Ponciano* and *Saint Apronius* (fig. 11), but also in the palette, in the use of light, and, above all, in the use of mannerist elements, evident in the contrasting proportions of figures, achieved by the use of the peculiar mannerist method to define space. Another example of this influence is Villalpando's *Ecce Homo* (fig. 12), in which we see the style of the founder of the Echave family as it was assimilated by his grandson, Echave Rioja, who was probably Villalpando's mentor. Furthermore, many human figures in Villalpando's paintings reveal an expressionist approach similar to the one used by Echave Rioja in *The Martyrdom of Saint Peter Arbúes* (fig. 13). This work is a good

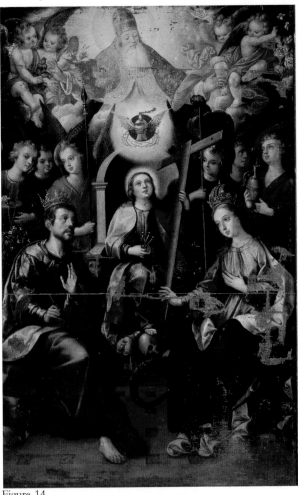

Figure 14

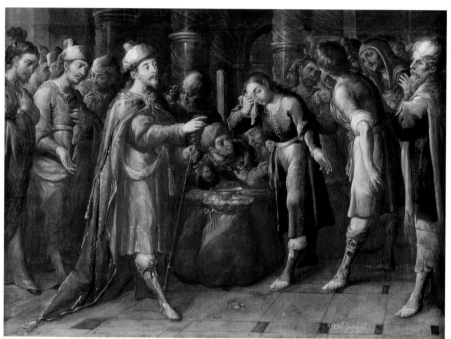

Figure 15

example of the influences of contemporary painters combined with those of their predecessors.

The traditions of past masters were transmitted not only in formal considerations, but also in iconographic details; a good example is the crown of thorns above the head of the Child Jesus in Villalpando's *Holy Family* (fig. 3), an element from the work of Luis Juárez (1590?–1639?; fig. 14). In spite of the formal differences between Echave Orio and Luis Juárez, they both made use of the mannerist vocabulary. Stylization of elongated figures in elegant and mannered poses so fascinated Villalpando that towards the end of his life he was called a neo-mannerist painter, as no other adjective fit him so well (fig. 15). Figures such as his *Saint Michael*, the archangel that he most favored, *Saint Louis King of France, Saint Barbara,* and the *Virgin of the Apocalypse* show elements that, though they could be considered archaic, nevertheless achieve great modernity in his hands. It comes as no surprise that a painter aware of the value of tradition would borrow mannerist elements from the early masters of New Spain and elsewhere.

122

Another example of the adaptation of local models is seen in works such as *Saints Justus and Pastor* (fig. 16), where many links exist with the work of the same title by José Juárez (fig. 17), in spite of distinct differences. One wonders whether Villalpando copied the painting or merely intended to use it as a model. The scenes in the background, which narrate the lives of the saints, are extremely mannered. Another example is his *Lactation of Saint Dominic* (fig. 4), which alludes to the *Appearance of the Virgin and Child to Saint Francis* by José Juárez (fig. 18). The similarities here are in the semicircular composition around an axis, a device much used by Villalpando in other paintings. The axis provides vertical possibilities along with yet more dynamic diagonal elements. In his *Martyrdom of Saint Lawrence* (fig. 19), Villalpando could have followed the engraving made of Titian's painting (fig. 20), but rather than a bailiff, he had an angel soothing Lawrence on the grill, like Juárez (fig. 21), thereby giving the work a de-

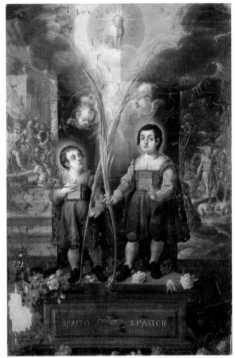

Figure 16

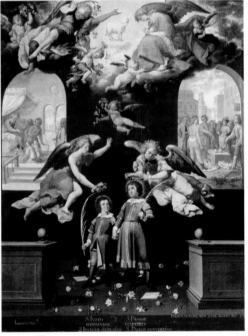

Figure 17

votional sweetness missing in Titian's work, but perfectly in tune with the spirit of New Spain.

It is obvious that Villalpando was as much a follower of local painters as he was of the "king's painters," including Titian, Rubens, Rizi, and Juan Carreño de Miranda. His accomplishments stemmed from an artful blending of both foreign and local influences. By the mid-seventeenth century, every cultured person in New Spain was convinced that it possessed a pictorial tradition that merited following. José Juárez, one of the most admired painters, was the son of Luis Juárez, who played an important role in the adaptation of the mannerist approach to the painting of New Spain. Even though the son adopted a naturalistic vein thanks to the introduction of the baroque, traces of his father's style survived. José Juárez, as previously noted, is recognized as the mentor of Baltasar de Echave Rioja, whom we have closely linked to Cristóbal de Villalpando;

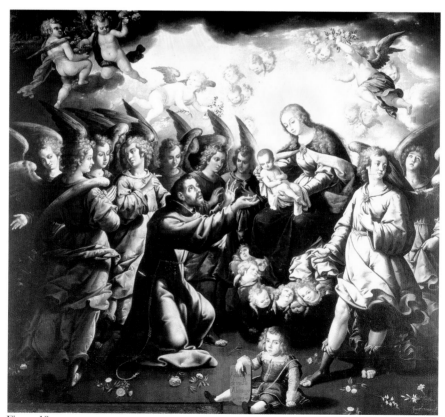

Figure 18

124

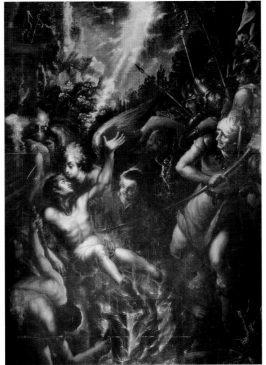

Figure 19

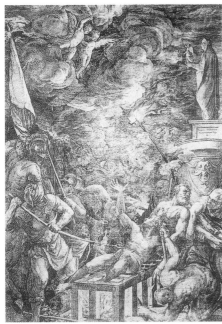

Figure 20

Figure 21

therefore, it can be said that Villalpando considered his tutor not only as part of a prominent family of painters but also as the creator of a new interpretation of the New Spanish legacy. Also significant is the fact that artists such as Villalpando adhered to tradition, in this case represented by three generations of the Juárez family, at the risk of including certain archaic elements. The only possible explanation is that he recognized this tradition as his own.

Perhaps for this same reason, the school of painting of New Spain never completely abandoned the elegant gestures, elongated deformations, and contrived designs of mannerism. Like many others, Villalpando considered himself a disciple of a master; therefore he not only copied but reinterpreted the legacy of his predecessors, adding to the story and technique what was appropriate to his times, with no intention of perfecting the legacy, but simply in order to develop it through innovations built upon the past. This is precisely what Villalpando did when he translated Echave Orio, Luis Juárez, or José Juárez. Rather than desiring to correct, he followed a pictorial intuition begun years earlier by the first painters in the land. If he had felt the need to correct the work of these masters, he would have concluded that it was not worth following.

In proudly building upon pictorial traditions and in transmitting his fresh interpretations to future generations, Villalpando represents a relevant generational nexus in the painting of New Spain. His strong influence is evident in the painters of the eighteenth century; and Miguel Cabrera's *Virgin of the Apocalypse,* at the Guadalupe College of the Propagation of the Faith, in Zacatecas (fig. 22), is but one example of Cabrera's tribute to Villalpando's painting in the sacristy of the Mexico City Cathedral (fig. 23).

Translated by Margarita González Arredondo

Figure 22

Figure 23

127

Notes

1 Carlos de Sigüenza y Góngora, *Triunfo Parténico que en glorias de María Santísima, Inmaculadamente concebida, celebró la Pontificai, Imperial y Regia Academia Mexicana* (México, Ediciones Xochitl, 1945), 104.

2 See *Cristóbal de Villalpando,* ed. Juana Gutiérrez et al. (México: Fomento Cultural Banamex, Instituto de Investigaciones Estéticas, Consejo Nacional para la Cultura y las Artes, 1997).

3 Rogelio Ruiz Gomar, "Nuevas noticias sobre los Ramírez, artistas novohispanos del siglo XVII," *Anales del Instituto de Investigaciones Estéticas, México,* 77 (2000): 67–121.

4 Juana Gutiérrez Haces, "La Transfiguración," in *Cristóbal de Villalpando,* 64–71, 194–197, and 64–71.

Figures

Frontispiece Detail of figure 6.

Figure 1 Plaza of Independence, Quito, Ecuador.

Figure 2 Anonymous, *Virgin of Quito,* 1725-50, polychromed wood with silver. Denver Art Museum.

Figure 3 Lower corridor of cloister, Monastery of Saint Augustine, Quito, Ecuador.

Figure 4 Miguel de Santiago, *Saint Augustine, Light of the Doctors,* from the series *The Life of Saint Augustine,* 1653-1656, oil on canvas, 200 x 250 cm. Monastery of Saint Augustine, Quito, Ecuador.

Figure 5 Miguel de Santiago, *The Rule of Saint Augustine,* 1656-1658, oil on canvas, 800 x 600 cm. Church of St. Augustine, Quito, Ecuador

Figure 6 Miguel de Santiago, *Holy is His Name,* from the series *The Christian Doctrine,* 1670, oil on canvas, 133 x 199 cm. Museum of Fray Pedro Gocial, Monastery of Saint Francis, Quito, Ecuador.

Figure 7 Miguel de Santiago, *The Demonic Possession of an Indian Woman,* from the series *The Miracles of the Virgin of Guadalupe (Guápulo),* ca. 1699 – 1706, oil on canvas, 140 x 84 cm. Sanctuary of Guápulo, Guápulo, Ecuador.

Figure 8 Anonymous, *Annunciation*, from the series *Life of the Virgin,* eighteenth century, oil on canvas, 94 x 81 cm. Monastery of the Immaculate Conception, Loja, Ecuador.

Figure 9 Bernardo Rodríguez, *The Last Supper with Saint Francis of Assisi and Saint Pedro of Alcántara* (detail), 1780, oil on canvas, 213 x 585 cm. Collection of the Church of Saint Francis, Museum of Religious Art, Popayán, Colombia.

Figure 10 Antonio Salas, *Saint Ann and the Child Mary,* 1838, oil on canvas. Convent of Saint Augustine, Quito, Ecuador.

Figure 11 Joaquín Pinto, *Oration in the Garden,* 1892, oil on canvas, 200 x 180 cm. Sacristy of the Convent of Merced, Quito, Ecuador.

Miguel de Santiago (c. 1633–1706):
The Creation and Recreation of the Quito School

Alexandra Kennedy-Troya
Universidad de Cuenca, Ecuador

This essay synthesizes the theoretical discussion generated by art specialists between 1930 and 1995 with respect to the existence or inexistence of a Quito School. The baroque painter Miguel de Santiago—called "protobaroque" by some, "eclectic" by others—is mentioned in many of their works as a crucial figure in the consolidation of a school or artistic center at the end of the seventeenth century that was concentrated particularly in the city of Quito, capital of the judicial district of Quito, at that time a dependency of the Viceroyalty of Peru (fig. 1).

However, the great majority of studies emphasize matters of style and consequently underline the degree to which local painting was indebted to foreign models at hand. Without abandoning matters of style, this essay aims to approach the topic in a broader context including considerations such as the creolization (*criollización*) of American societies in general, and the question of appropriation by the artists of images to serve their particular realities—in this case, baroque images created from

Figure 1

131

the perspective of the local powers in Quito. To this end, and as an exercise or case study, I have selected three key pictorial series by Santiago created in diverse stages of his career: *The Life of Saint Augustine* (1653–1656, Monastery of Saint Augustine, Quito), *The Christian Doctrine* (c.1670, Museum of the Monastery of Saint Francis, Quito), and *The Miracles of the Virgin of Guápulo* (c. 1699–1706, sacristy, Church of Guápulo, Quito).

Nearly a century and a half after his death, the paradigmatic figure of Santiago was redeemed as a bridge between the art of the colonial period and Romantic art of the second half of the nineteenth century, within the context of the theoretical construction of the new Ecuadorian nation. The conservative sector saw in him, and in what was believed to be the Golden Age of the arts in Quito—the seventeenth century and beginning of the eighteenth century—the foundation of a nationality, and the natural model par excellence for the development of future artists. These perceived connections appeared to be seamless; they strengthened continuities and seemed to perpetuate the waning power of the conservative and aristocratic landowner class in the highlands of Ecuador during the nineteenth century.

Miguel de Santiago and the Creation of the Quito School

Intellectuals and historians of Ecuadorian art have disagreed concerning the existence or inexistence of a Quito School. The discussion was particularly fervent between 1930 and 1950, and it coincides with two events worth mentioning: the *Indigenismo* (Indigenism) movement in literature and the arts, and the need to reconstruct a new identity for the country after the cession of a great part of Ecuadorian territory to Peru in 1941.

On one hand, the *Indigenismo* movement openly denounced the ill treatment of the indigenous sector of the population, and it proposed to find methods for a more equitable integration. Among these solutions, the *blanqueo* or "whitening" of indigenous society was perhaps at least considered, although very different from today's way of thinking. On the other hand, some intellectuals, such as Alfredo Pareja Diez-Canseco, expressed a need to accept Ecuadorians as *mestizo* people, a point of view that Diez-Canseco clearly manifested in a 1952 historical novel about the painter

Miguel de Santiago. Additionally, the territorial conflict had brought about a certain moral—not only political or economic—disintegration of the Ecuadorian population. Culture, not guns, would surely be the best weapon for the reconstruction of the country, maintained the renowned intellectual Benjamín Carrión, one of the creators of the Casa de la Cultura Ecuatoriana (House of Ecuadorian Culture) in 1944.

In this context, Ecuadorian art and its history had to be rescued, redefined, and promoted in order to give voice to a new form of nationalism. In 1936, Luis Felipe Borja, a historian and politician from Quito, carefully defended his preference for referring to Quito as an artistic center rather than to a Quito School. "It is true that to a certain extent our national pride is hurt, but the fact that Quito had been a great artistic center that had disseminated its wonders in the American continent and had been appreciated with praise even by the authorities of the Old World is a great honor." Víctor Puig, Spanish art professor and art critic residing in Quito, had expounded similar ideas (Borja 1936, 62).

The debate began by distinguishing architecture from other artistic manifestations. At the time, architecture was believed to be the only type of art sufficiently worthy to enable Quito to be considered "the principal center of artistic expansion in the northern part of our continent," in the words of the Argentinean Martín Noel (cited in Vargas 1944, 12). Ecuador's first art historian, José Gabriel Navarro, had already mentioned the preeminence of Quito's architecture. "Quito…is an art school, if not in painting, an area in which its contribution is minor, then (certainly) in sculpture and most of all in architecture" (cited in Borja 1936, 57).

The root of the problem for these intellectuals was the matter of originality. Valentín Iglesias, an Augustinian who in 1922 published a short descriptive work about the series of the *Life of Saint Augustine* by Miguel de Santiago and his collaborators, had discovered prints by Flemish Schelte de Bolswert on which the composition of some of the works in the series had been based in part. Since then, those who believed in the existence of a Quito School had attempted, at all costs, to refute the "detractors," basing their arguments on the concept of a unique artistic expression determined by the artist's use of color, the inclusion of indigenous charac-

teristics in the faces of the portrayed, or the appearance of some tropical fruit on a *retablo*. One of the primary defenders of the Quito School was Father José María Vargas, a Dominican, who constructed the historical foundation of Ecuadorian art, a true initial inventory of the colonial arts. He assumed that the Quito School embraced all of the artistic conventions created in the judicial district of Quito, though he never defined those characteristics. Years later he came to believe that a Cuenca School also existed, to the south of Quito, with a more elaborate style, more movement, and a stronger use of *dorados* (gilding) than the Quito School. This latter proposal, however, has not had any support worth mentioning.

Not until late in the twentieth century were new approaches introduced to define and interpret the Quito School within the American context. The discussions in regard to style continued to be valuable even though the protagonists had different political interests and theoretical positions. One point of view would be expressed by Mario Monteforte, a sociologist of Guatemalan art, who "saved" Quito's architecture as "production with sense…as a result of the modalities with which it adapts the foreign originals, the peculiar way in which styles are fused, the inclusion of extraordinary anachronisms, and an excess of decorative elements" (Monteforte 1985). According to Monteforte, the rest—sculpture, painting and utilitarian arts—was simply an appendix of Spanish art, and not a "reflection of a society constantly evolving due to class dynamics, and nations and nationalities in formation." "All conflicts," he added, "barely leave a mark in the arts."

In 1989 Alfonso Ortiz and I proposed a similar position, with the central argument that there were no indigenous elements—thematically or stylistically—included in any of the arts during the period in question. In addition, in comparison with similar artistic manifestations in Cuzco or Potosi, the arts in Quito could be considered "classical" and very much indebted—especially sculpture—to works produced in Castile and Andalusia in Spain. Accordingly, my 1993 article "La esquiva presencia indígena en el arte colonial quiteño" (The Elusive Indigenous Presence in the Colonial Art of Quito) intended to explain the reasons for the absence of an indigenous painting style in Ecuador in spite of the high density of Indian

134

population in this region. At present, however, we recognize that the question regarding the orthodoxy of painting in Quito, or in Lima, to cite a similar case, will have to be approached in a different, nontraditional manner, incorporating different types of study subjects such as celebrations, indigenous dancers, and their music and vestments, as Susan V. Webster observed recently in a collective work edited by me and published in Spain (2002).

In her studies of Quito's colonial sculpture, Gabrielle Palmer, an art historian from the United States, established its indelible debt to Spanish sculpture (fig. 2). She also reexamined the existence of a Quito School, comprising art produced in the city of Quito once a characteristic style was consolidated, a position she explains extensively in her work. According to Palmer this moment transpired between 1730 and 1830 (1987, 65).

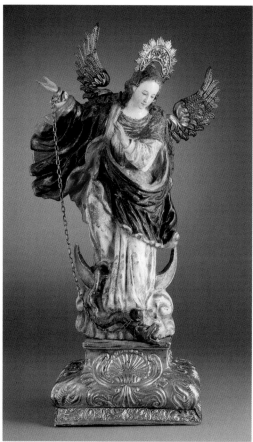

Figure 2

Attempts to Redefine the Quito School

In 1994 the historian Rosemarie Terán, in an essay on the art produced under the sponsorship of the Virgin of the Rosary guilds in the Santo Domingo Monastery of Quito, rejected the analysis that I had proposed. Her interest was focused on more anthropological aspects of art, guided by new ways of perceiving the image as an instrument of power, an approach proposed by the French theorist and anthropologist Serge Gruzinski. Even though Terán's studies lacked an adequate treatment of the artwork as such, the proposal turned out to be very interesting. "Artistic style" was not merely imposed in an exogenous manner, but selected within a colonial society as a solution. An anachronistic iconography could correspond to a strategy of cultural transformation by the local status quo in pursuit of new supporters during times of crisis. Asian and indigenous influences, for example, could be complementary if their circumstances were compared. These "elections" or "choices"—conscious or unconscious—would contribute to the formation of an art from Quito, different from the art of Andalusia or Cuzco.

It was impossible to dissociate the religious art that resulted from the Counter Reformation in America, as a production of style or styles, from the political intention of all the images in the service of those who sponsored them. Did not these types of languages—especially visual and auditory—become the only real instrument to transform the collective unconscious in societies that well into the seventeenth century were considered "unlettered" and "heretic"? Was not the so-called classic baroque, or orthodox in the case of Quito, merely another attempt by the forces of power in this particular society, so different from the Inca elite of Peru or Bolivia, to "attack" or oppose the transformation of their own native population? Is this not a wider formula for observing the formation of a more local creole spirit, more its own?

Painting in the School of Quito, if we insist on the term, shows a considerable decrease and simplification of iconographic themes, care in the classic representation of naturalistic images, a moderate and extremely meticulous use of the matte gold that is used to draw the contours or to insinuate volume (very different from the decorative and excessive char-

acter of the brocaded gold overlay in Cuzco painting, to take the most outstanding example). The presence of the Eucharist, the triangular virgins of Pomata or Cocharcas, or the harquebusier archangels is not as thematically important as in the Andean south. In Quito, there seems to be an insistence on representing the scene as realistically as possible by stressing the veracity and naturalistic details of the local landscape or the individuals depicted.

We can therefore talk about a *mestizo* "art" or material culture—whether it is called art or not—that was produced in the dominant urban sectors of Quito during the second half of the seventeenth century, by figures such as the painter Miguel de Santiago. This type of representation served the needs of the new church and administration in Quito that provided commissions to Santiago and other painters. These artists, meantime, were adapting their personal styles in a kind of pictorial shift to express "universally irrefutable" truths that they accommodated to the local reality.

A Baroque Image That Strengthens the Power of the Local Church: The Saint Augustine Series

The figure of Miguel de Santiago is intimately related to the Church of Quito through commissions he received, especially from the nonsecular, or regular, clergy, which in those years was declining. At that time, the secular clergy was gaining more and more power in Latin America; between 1650 and 1675 there were more secular archbishops than nonsecular ones. Between 1600 and 1750, the missions, administered by the nonsecular clergy, were gaining strength, as the number of new secular dioceses diminished. Nevertheless, at the same time, the episcopate was becoming more secular and creole. That is, the church in America was being administered more and more by secular creole clergy who belonged to the elites of power. As an additional challenge, the nonsecular clergy had to deal with indigenous displeasure with the new requirement that Indians should be catechized in Castilian so that the exposition of religious truths would be more accurate, reintroducing the problem of language (*La Iglesia en América* [*The Church in America*] 1992, 173).

Figure 3

To strengthen the image of the nonsecular clergy and to assure its continuance seems to have been the generalized policy of the nonsecular orders, a policy in which painters played a crucial role. Miguel de Santiago, for example, was hired by the Monastery of Saint Augustine in Quito in 1653 to create part of the series of *The Life of Saint Augustine* that would occupy, as was common, the cloisters of the monastery (fig. 3). Only 12 to 14 of the 25 paintings that composed this magnificent series were created by the master (fig. 4); other artists, known as Bernabé Lovato and Simón de Valenzuela, worked with Santiago on this great project. To support it, the provincial Father Basilio de Ribera and Father Leonardo Araujo had brought from Rome prints of the *Life of Saint Augustine* series created in 1624 by the Fleming Schelte de Bolswert. Schelte de Bolswert was an artist linked to Plantin-Moretus, a well-known publishing house in Antwerp, which supplied many printed images to Latin America.

Although it is known that for some of the paintings—for example, *The Death of Saint Augustine* and *The Funeral of Saint Augustine*—Santiago used print sources by Bolswert, known as the best interpreter of Rubens's work, it is clear that he worked with relative independence. His characters are monumental and he creates a dramatic composition in which he

138

Figure 4

applies mannerist principles to his figures combined with a baroque un-
derstanding of light and space. On the other hand, within this great sobri-
ety, Flemish principles favored by the Quito painters are incorporated in
details reminiscent of Gerard de Jode, Martin de Vos, and the Italians. In
addition, the Quito painter makes an effort to create settings with details
of the flora, fauna, and furniture typical of Quito, as in the case of *The
Priestly Ordination of Saint Augustine* and *The Birth of Saint Augustine*
(Vargas 1964, 93ff).

In this series the painter contributes to the construction of a new
heraldry, with coats-of-arms representing the donors who financed it in-
serted into the work. This collective patronage included court function-
aries such as doctor president of the Audiencia of Quito Pedro Vázquez
de Velasco, judges Juan de Morales Aramburo and Luis José Mello de la
Fuente, individuals of the Quiteñan church, accountants, chief magis-
trates, merchants, and commissaries of the Holy Office.

Barely more than twenty years of age, Santiago would displace the
traditional artist workshops in San Francisco and Santo Domingo and would
set up the best team of collaborators of the time. The Augustinians had
begun a process that today we would consider marketing. After this series,
the same convent commissioned Santiago to create one of the most ambi-
tious works to be produced in Quito: *The Rule* (presently at the church),
a work of enormous dimensions that would represent the order's

Figure 5

genealogy, providing the opportunity for Santiago to display his great talent as a portraitist (fig. 5). It is possible that another painting of the same theme at the Augustine convent in Lima is related to this work, as well as others that are reminiscent of Santiago's style and that corroborate his influence on the neighboring provinces. It seems to me that these works correspond to a time of the Augustinian order's consolidation, and would also get Santiago new commissions from other nonsecular orders that were required to implement the new rules for catechizing.

Art and Catechesis for "Heretics": The Christian Doctrine

In the specific case of Quito, the content of the first synod celebrated in the city in 1570, and promoted by the archbishop friar Pedro de la Peña, was directly related to the teaching of the Christian doctrine and the administering of the sacraments. Peña recommended a methodology that would be sure to facilitate learning, so "he sent priests and religious men to create signs or posters bearing the Creed, the Lord's Prayer, and the Hail

140

Mary, so that the Indians and Spaniards would have them on view" (*Los siglos de oro* [*The Golden Centuries*], 335).

Almost a century later, however, in 1668, Archbishop Alonso de la Peña Montenegro published in Madrid the *Itinerario de párrocos de indios* (Itinerary for Parish Priests of the Indians), in which he explicitly alludes to a native population still not yet indoctrinated.

> One of the biggest obstacles preventing the Indians from receiving the Christian Doctrine well, and from relinquishing their natural ferocity, and from entering the political life of men, is to reside in the mountains and along the rivers, away from the doctrine, the teaching of priests, and the political activity of the towns (Ortiz and Terán 1993, 205).

It is now known that during these years, despite the archbishop's words, the countryside was becoming depopulated. Having already endured the aborted *encomienda* project of indigenous resettlement and the successful one of monopolizing their labor for manufacture or textile factories begun in the seventeenth century, some indigenous people saw no solution to their difficult situation other than to leave the countryside and go to the Spanish towns in search of work and better living conditions. It is quite probable that the religious strategy used by the nonsecular orders situated in urban areas had to be redefined for a new population of immigrant Indians who, according to Archbishop Peña Montenegro (Ortiz and Terán 1993, 227), still "lived in gentilism" and "appreciated only the ceremonial." Among other tasks, the parish priests had to teach the Indians to "often make the sign of the cross, to say the Creed, the Pater Noster, and the Hail Mary..." (Ortiz and Terán 1993, 244).

As was to be expected, Archbishop Peña Montenegro's ideas, as well as those of the president of the jurisdiction of Quito between 1674 and 1678, influenced the doctrinarian behavior of the orders. Interestingly, a painting attributed to Miguel de Santiago by Vargas represents the archbishop himself, handing over to the abbess a model of the new Carmelite convent, moved from Latacunga to Quito after a violent earthquake (Low Carmelite Convent, Quito).

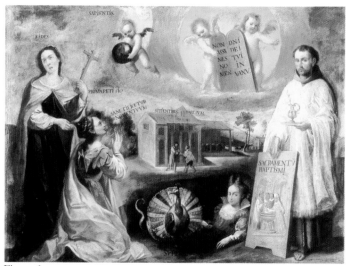
Figure 6

This local Counter-Reformation spirit can be noted in concrete examples. The urgency to continue indoctrination, the catechist spirit, and the preference for the baroque image motivated the transformation of the imaginary into a pictorial vocabulary. Santiago constitutes the best example of a painter in the service of this spiritual reinforcement, directed to the Indians as well as their white or *mestizo* urban neighbors. The doctrinal series found in the monasteries of Saint Francis in Quito and Bogotá, as well as in the Cathedral of Quito, can be read as open books describing this process. Significantly, their conception and manner of presentation are unheard of in the history of art, as Santiago Sebastián points out.

In each one of the eight works of the *Christian Doctrine* (fig. 6), presently at the Museo de San Francisco de Quito, as well as its copies and sketches located in the Carmelite Convent of the Assumption in Cuenca, the painter combined, in a personal and unprecedented manner, the seven gifts of the Spirit, setting the virtues (commandments) against the vices; the seven mortal sins; the seven sacraments; the seven works of mercy; and the Lord's Prayer (see Vargas 1981).

Another series of eleven paintings of similar composition and style, *The Praised*, was sent to the counterpart monastery in Bogotá in 1673, and included the phrase "Praised be the Sanctified Sacrament of the Altar and Mary conceived without the taint of original sin." The parish priests

142

taught the Indians to utter this phrase before and after their daily chores, and it is still present on the upper area of the entryway from the cloister to the church of San Francisco in Lima. *The Praised* shows the masculine world of the Church in contrast to the feminine represented by the *Conception of Mary*.

Another doctrinal series of twelve works—*The Articles of the Creed*—was sent to the Cathedral in Bogotá the same year. It depicts truths about the Father, the Son, and the Holy Spirit. Some of the images are based on prints by Martin de Vos. In terms of style, these represent the work of a painter known for his command of freer compositions, an open and quick drawing, and a palette of much lighter colors. Both series are related to the one in San Francisco de Quito.

Baroque Themes Applied to Local Realities: Death in the Series *The Miracles of the Virgin of Guápulo*

Death as an almost obsessive reminder of the ending of life not only is present in baroque Counter-Reformation discourse, but was also part of the daily life of people in Quito. We should remember that during the second half of the seventeenth century this region suffered earthquakes and volcanic eruptions, floods and lengthy droughts. At the end of the century prophecies of new destructions were ubiquitous. "Every day at daybreak, the ones that were most scared peered through the lattice window, their eyes riveted on the volcanoes. There were more penances, novenas, and offerings than in many years," according to Pareja's novelized reconstruction of the historic moment in which Miguel de Santiago lived (1952, 112).

At the beginning of his career, Santiago had represented death through historical-theological paintings such as the *Death of Saint Augustine* (from the *Life of Saint Augustine* series, Saint Augustine Monastery), *Descent of Christ* and *Agony of Saint Augustine of Tolentino* (Chapter House, Saint Augustine Monastery), *Dream of the Virgin* (Trascoro, Cathedral of Quito), or *Christ of Agony* (which disappeared). At the end of his career, he would link death to events of his local and contemporary reality, for example in

143

Figure 7

the series of the *Miracles of the Virgin of Guápulo* (c. 1699–1706, Sacristy, Monastery of Guápulo) (fig. 7).

This series, created with Gorívar, was part of a more ambitious project initiated by the archbishop to secure a place of pilgrimage honoring the Virgin of Guadalupe or Guápulo. The small Indian town northeast of Quito was on the obligatory route for missionaries and settlers going to Ecuador's eastern rainforest zone. Perhaps the commission was an effort to compete with the Mercedarians, who had been gaining popularity through Our Lady of Mercy or of the Earthquakes, directly connected to the missions established in the eastern rainforest region.

Under the circumstances, it is not surprising that a painter of religious truths standing on the edge of his own contemporary world would modify his painting style. Perhaps the religious principals themselves were demanding it. On the one hand, Santiago celebrated with one of the most interesting works of his pictorial repertoire, the *Immaculate Conception with Philip IV and Alexander VII* (Monastery of Guápulo), a glorious event for the European Catholic Church, the significance and setting of which he transferred to Quito. On the other hand, surely moved by the miracles of the devout women from Quito, Mariana de Jesús and the Clarist nun Juana de Jesús, Santiago responded as we will see below.

In the same Guápulo series we can contemplate his capacity to transfer to the canvas miraculous events occurring among the indigenous people of the region. For example, take the scene showing the event in 1646

144

when, in the presence of Bishop Agustín Duarte and President of the Audience Martín de Arriola, a "possessed Indian woman" appeared dead during the high mass (fig. 7). At the end of the mass, she stood up "healthy and sound." The scene is explained in a legend in a cartouche in the lower part of the painting.

The majority of the works of this votive series of twelve canvases commissioned by the locals, surely members of the important Guápulo guild, narrate episodes in the rural life of the indigenous population related to diseases, droughts, and the natural setting around Quito. These are very different from the Flemish towns that inhabit the paintings of Saint Augustine. Not only have the themes and elements that occupied Santiago at the beginning of his career changed, but the new style he has created also shows a radical transformation.

The painter of 1653, whose works had been based upon a rather rigid palette, strong chiaroscuros, and mannerist-baroque compositions inspired in great part by Flemish prints, experienced a major change four decades later. His paintings now exhibited a new freedom that did not require print models, but rather identifies Santiago as an Andean landscape painter. He created a landscape into which he integrated the local setting of one miracle or another, in a quasi-impressionist style using warm colors inspired by the shimmering sun of Quito. He had become an artist who depicted a moment of intersection in local history, a history which his actors are appropriating, where each one resembles a chess character finding his or her position and from there attacking, creating a strategy for survival, withdrawal, or seizure.

Quito: The Center of the Quito School and the Configuration of a New Artistic Geography

If creating a "school" means consolidating not only a stylistic proposal, but one that responds to the circumstances of time and place with all the ideological and social burden with which they are freighted, then let me propose an idea already expressed in a different manner by other Ecuadorian colleagues, that during the second half of the seventeenth century the basis of an art school of Quito was being formulated.

The school had its center of training, production, and commercialization in the city of Quito. The exchange of artists and educators from the city, and the export of works of varying caliber, resulted in the gradual configuration of an artistic space that was geographically far-reaching, extending perhaps from Loja, south of Quito, to Santa Fe de Antioquia in the territory of New Granada, present-day Colombia (Kennedy 1995, 140). It is interesting to observe that in the case of Loja, the paintings created during the eighteenth century show characteristics of the Quito painting style as much as the Cuzco style. Perhaps this signifies a fusion of styles that warrants more study (fig. 8).

At the beginning this school was particularly linked to easel painting, and Miguel de Santiago is undoubtedly the most representative model of this phenomenon. But at the end of the century its influence—in sculpture as well—seems to have spread towards other Pacific South American areas, including Panama, Venezuela, Colombia, Peru, and Chile, and during the eighteenth century it extended to other regions such as Bolivia. The quantity of an almost industrialized production, the technical quality, the exportation of a "classical" baroque language, and the low cost of the

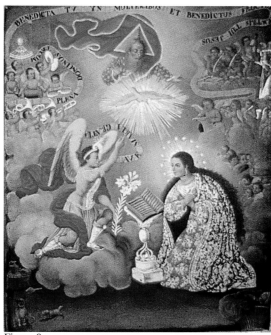

Figure 8

146

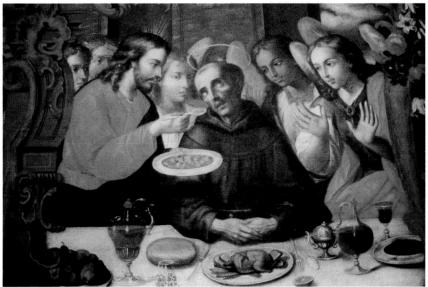
Figure 9

artwork of Quito were attractive, particularly for areas of modest artistic production, as in the case of Chile, which demanded artworks not only from Quito, but from Peru and Bolivia, throughout its entire colonial era (see Kennedy 1995, 1998, and 1999; fig. 9).

The Romantic Vision of the Colony in the Nineteenth Century

One of the most interesting topics surrounding the figure of Miguel de Santiago and what is referred to as the Golden Age of the arts in Quito is how this germinal artist and his era were later used as points of support and reference for the historicism and nationalism that developed in romantic art, particularly in Quito during the second half of the nineteenth century. During this period of revitalization of the arts—especially painting and drawing—the colony was beginning to be perceived with nostalgia, a longing for an era of lost magnificence before the crises that the Quito School had suffered during the first decades of the nineteenth century. Santiago would become the key figure in this process of appropriation, because of his inclusion of local themes such as miracles or historical scenes, landscapes of local reality, and authentic portraits of Quito's society, in addition to his contributions

Figure 10

towards a freer, more creative, and more "professional" or "classic" technique.

An attempt to take a retrospective look took place in 1849, when the second art school was created in Quito and was named after our painter: the *Liceo de Pintura Miguel de Santiago* (Miguel de Santiago Painting Lyceum). Directed by the French draughtsman Ernest Charton, who was visiting Quito, and sponsored by the influential and wealthy Angel Ubillús from Quito, this school lasted less than two years, even though noteworthy artists such as Ramón and Rafael Salas, Agustín Guerrero, and Luis Cadena, among others, were trained there. This was the first attempt to formalize the methodical teaching of the pictorial arts in Ecuador.

Starting from the foundation of this lyceum, the *Escuela Democrática Miguel de Santiago* (Miguel de Santiago Democratic School) was created in 1852. It lasted until 1859, when it closed because of political upheaval in Ecuador. Linked to the conservative painter Antonio Salas (fig. 10) and his workshop, the school was founded for political as well as artistic reasons. During its inauguration, the founders celebrated the anniversary of the "Marcist" Revolution of 1845 ending the abusive and totalitarian power of the first president of the Republic, the Venezuelan military man Juan José Flores (1830–1845). Although the speeches alluded to the necessity to eradicate "the conservatism behind religion" (Navarro 1991, 232), this was not so much going against Catholicism as it was a way to critique some members of the local church as having been favored by the ruling classes and having led corrupt lives. The goal of the new art, it was said, should be "inventing and having the originality to take on a national

character…so as to not beg science and inspiration from the nations that are the vanguards of civilization" (Vargas 1971, 15). In this context, Santiago became a meaningful figure because he had been an important interpreter of Catholicism—which gave these progressivist intellectuals a feeling of security—but he had given his images a new conception by representing his own Quiteñan environment in a freer style of painting.

The school promoted the first art competition in the history of the country. It is interesting to point out that among the awards and entries there were works in which colonial paintings were literally transcribed. That is the case of the colonial series attributed to Gorívar, a disciple of Miguel de Santiago, entitled *The Kings of Judea*, copied by Vicente Pazmiño, which received the sixth place award (Kennedy 1992)!

It is clear that the new schools of the arts in Quito were regarded as a continuance of the Golden Age of the arts in Quito, rather than as a rupture. In 1861, the conservative writer Juan León Mera recalled the creation of these schools:

> It was not many years ago when beneficent peace held out her hand to our disgraced nation, and various illustrious citizens and skillful artists founded a painting school in Quito, baptizing it with the name of Miguel de Santiago. The intention was to honor the memory of this famous professor, establish a real teaching system, encourage youth dedicated to progress through the study of painting, and stimulate them by showing them Santiago's great level of achievement, pursuing the goal with all of these joint efforts (Mera 1861, 146).

Miguel de Santiago, according to Mera himself, had had the "honor of creating a school and establishing his nation's good taste in painting" (Mera 1861, 145). This was perhaps the first time that the term "school" began to be used.

Seemingly, during the second half of the nineteenth century one of the common ways of learning was to turn to the most outstanding models of the colony found in churches and monasteries. The country had only one art museum, which was in a calamitous condition. The use of earlier colonial models as well as new imported images was accepted in artistic

circles, by both artists and the public. We have the impression, however, that the use of local models was selective. The baroque period was preferred, with Santiago and Gorívar as the period's leading representatives, followed by the rococo of the last quarter of the eighteenth century, and the art of the first three decades of the nineteenth century, led by painters such as Bernardo Rodríguez and Manuel de Samaniego, who enjoyed great success within and outside Ecuador's borders. This topic still needs to be studied.

This process of turning to colonial models seems to have continued until the early years of the twentieth century. For example, in 1905 the prominent romantic painter Joaquín Pinto (fig. 11) copied in pencil one of Santiago's works from the series of the *Life of Saint Augustine: The Miracle of the Weight of the Candle* (Museo Casa de la Cultura Ecuatoriana, Quito). Pinto based many of his religious paintings on Santiago's teachings, as well as on those of his disciple Gorívar (Joaquín Pinto 1983–1984, n.p.). Even more surprisingly, Pinto's drawing was the basis for an oil painting

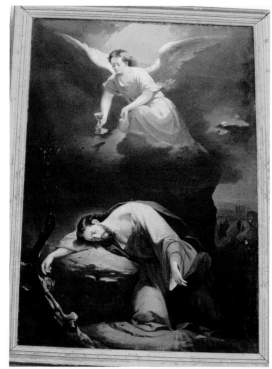

Figure 11

by the symbolist Víctor Mideros, and in 1940 it was displayed in the Gallery of El Comercio, though today its whereabouts are unknown (Pérez Concha 1942, 90).

Santiago's importance as a national symbol was also upheld through the intervention of the conservative president Gabriel García Moreno, who, according to Celiano Monge, in 1865 provided the funding to settle a lawsuit that Saint Augustine's dependency school had filed

150

against the Augustinians for not paying its teachers. This prevented the confiscation of Santiago's works to pay the debt, after an expert appraisal was done by Luis Cadena and Rafael Salas, the most outstanding painters of the time (Pérez Concha 1942, 101). Years later the Spanish sculptor González y Jiménez was employed to classify Santiago's works, giving cause for new discussions about them (Pérez Concha 1942, 90).

The artistic admiration for Santiago was promoted by the conservative elite segments of highland society and had its correlates in the country's literature. One of the first theoreticians of Ecuadorian art, Juan León Mera, had written an article on Miguel Santiago in 1861. In his famous essay of 1894, "Concepto sobre las artes" (Observations about the Arts), he stated that Santiago "composed what he painted: he was a creator"; if Antonio Salas was an outstanding modern painter, his stature was due in great part to his passion for Miguel de Santiago. Salas, Mera reported, "frequently spent long hours contemplating the canvas of the great master in the cloisters of Saint Augustine, and even copying parts of them to imitate the draftsmanship, the coloring and the expression of his paintings insofar as possible" (Mera 1894, 304).

Conclusions

Seemingly, the School of Quito developed during the second half of the seventeenth century around the figure of one painter: Miguel de Santiago, who worked and sold from his workshop in the city of Quito. Ever since that time, baroque and rococo painting in Quito have been greatly valued and have been in demand not only within the city and the judicial district, but also throughout America and Spain.

Although the exportation of artwork began with painting at the end of the last third of the seventeenth century, and intensified with the shipment of sculptures and other utilitarian arts and handicrafts such as rosaries and buttons during the eighteenth century, it is important to distinguish the area of actual influence from that of wider dissemination. Geographical proximity to Quito seems to have directly influenced the production of an area from Loja, south of the judicial district of Quito, to Santa Fe de Antioquia in the south-central zone of today's Colombia,

studied not long ago by the Colombian researcher Gustavo Vives (1998). A more extensive radius of activity included all those regions that were recipients of artwork from Quito: occasionally Mexico, for example; more regularly Bogotá or Lima; and even more intensely Santiago or Concepción in Chile. In this broader context, the artistic production of the recipient areas does not appear to have been substantially modified by the introduction of Quiteñan art.

Apparently, the guiding principles of the Colonial Latin American schools were linked to the creolization and appropriation that the American artist made of his institutions, government, and material culture, among other elements. In this process a baroque painter such as Miguel de Santiago makes an interesting case to study, since his first works were linked to external models, but slowly his production became freer and began to incorporate local themes, portraiture, and landscapes with which he was intimately familiar, as well as a technique that became increasingly more authentic and personal. Santiago, then, developed new options to satisfy local responses.

Santiago and the dozens of artists who subsequently composed what has been called the Quito School have been revisited during periods of history that required reconstructing local identities. During the second half of the nineteenth century, baroque art, particularly painting, and to a certain degree some of the contributions of the rococo were seen as the Golden Age of art in Quito. Romantic artists and conservative theorists closely studied the colonial models found in churches and convents. They promoted the value of the colonial artistic paradigm in pursuit of the reconstruction of the Ecuadorian nation. In this sense, Santiago was seen as a pioneer, a model of the creative, and a "national" artist who should be emulated. But between 1930 and 1950 the Quito School was revisited again, with different nuances and motives; now, its artists and their works were seen as symbols of the foundation of a racially mixed, or *mestizo*, nation.

Bibliography

Borja, Luis F. 1936. "Algo sobre arte quiteño." *Boletín de la Academia Nacional de Historia* 40 (Quito, July–Dec.): 55–63.

Giraldo Jaramillo, Gabriel. 1956. *Pinacotecas bogotanas*. Bogotá: Ed. Santafé.

Herrera, Pablo. 1890–1891. "Las bellas artes en el Ecuador." *Revista de la Universidad del Azuay* 3 (Cuenca, May 1890): 102–104; 6 (Aug. 1890): 191–195; 7 (Sept. 1890): 223–227; 17 (Oct. 1891): 148–150.

La Iglesia en América: evangelización y cultura. 1992. Pabellón de la Santa Sede, Sevilla: Exposición Universal de Sevilla.

Iglesias, Fr.Valentín. 1922. *Miguel de Santiago y sus cuadros de San Agustín*, 4th ed. Quito: Prensa Católica.

Joaquín Pinto. Exposición antológica. Exh. cat. (1983), curated with texts by Magdalena Gallegos de Donoso, Dec. 1983–Mar. 1984. Quito: Museo del Banco Central del Ecuador.

Kennedy, Alexandra. 2002. "Algunas consideraciones sobre el arte barroco en Quito y la 'interrupción' ilustrada (siglos XVII y XVIII)." In *Arte de la Real Audiencia de Quito, siglos XVII y XIX. Patronos, corporaciones y comunidades,* ed. Alexandra Kennedy, 43-65. Hondarribia: Editorial Nerea.

———. 1992. "Del taller a la academia. Educación artística en el siglo XIX en Ecuador." *Procesos Revista Ecuatoriana de Historia* 2 (Quito): 119–134.

———. 1993. "La esquiva presencia indígena en el arte colonial quiteño." *Procesos Revista Ecuatoriana de Historia* 4 (Quito): 87–101.

———. 1995. "La pintura en el Nuevo Reino de Granada." In *Pintura, escultura y artes útiles en Iberoamérica 1500–1825,* ed. Ramón Gutiérrez, 139–157. Manuales de Arte Cátedra. Madrid: Ediciones Cátedra S.A.

———. 1998. "Circuitos artísticos interregionales: de Quito a Chile. Siglos XVIII y XIX." *Historia* 31 (Santiago): 87–111.

———. "Quito un centre de rayonnement et d'exportation de l'art Colonial." In *La grâce baroque, chefs-d'oeuvre de l'école de Quito,* exh. cat. (1999), curated by Alexandra Kennedy and John Sillevis, June 18, 1999–January 23, 2000, 63-69. Nantes/Paris: Musée du Château des Ducs de Bretagne/Maison de l'Amerique Latine.

Kennedy, Alexandra, and Alfonso Ortiz. 1989. "Reflexiones sobre el arte colonial quiteño." In *Nueva Historia del Ecuador,* ed. Enrique Ayala, vol. 5, Epoca Colonial III, 163–185. Quito: Corporación Editora Nacional/ Grijalvo.

Mera, Juan León. 1861. "Miguel de Santiago." *El Iris. Publicación literaria, científica y noticiosa* 9 (Quito, November 20): 141–147.

———. 1894. "Conceptos sobre las artes (1894)." *Teoría del arte en el Ecuador,* intro. Edmundo Ribadeneira, Biblioteca Básica del Pensamiento

Ecuatoriano XXXI, 291–321. Quito: Banco Central del Ecuador/ Corporación Editora Nacional, 1987.

Monteforte, Mario. 1985. *Los signos del hombre. Plástica y sociedad en el Ecuador.* Cuenca/Quito: Pontificia Universidad Católica del Ecuador/Universidad Central del Ecuador.

Navarro, José Gabriel. 1991. *La pintura en el Ecuador. Del XVI al XIX* (c.1950). Quito: Dinediciones.

Ortiz Crespo, Alfonso, and Rosemarie Terán. 1993. "Las reducciones de indios en la zona interandina de la Real Audiencia de Quito." In *Pueblos de indios. Otro urbanismo en la región andina,* ed. Ramón Gutiérrez, 205–255. Col. Biblioteca Abya Yala 1. Quito: Ediciones Abya Yala.

Palmer, Gabrielle. 1987. *Sculpture in the Kingdom of Quito.* Albuquerque: University of New Mexico Press. There is a Spanish translation by Alfonso Ortiz Crespo, *La escultura en la Audiencia de Quito* (Quito: I. Municipio de Quito / Dirección de Educación y Cultura, 1993), without illustrations.

Pareja Diez-Canseco, Alfredo. 1952. *Vida y leyenda de Miguel de Santiago.* México: Fondo de Cultura Económica.

Pérez Concha, Jorge. 1942. "Miguel de Santiago." *Boletín de la Academia Nacional de Historia* 22 (Quito): 82–102.

Sebastián, Santiago. 1990. *El Barroco Iberoamericano. Mensaje iconográfico.* Madrid: Ediciones Encuentro.

Los siglos de oro en los virreinatos de América 1550-1700. Exh. cat. (2000), curated by Joaquín Bérchez, Museo de América, November 23, 1999–February 12, 2000. Madrid: Sociedad Estatal para la Conmemoración de los Centenarios de Felipe II y Carlos V.

Terán E., P. Enrique. 1950. *Guía explicativa de la pinacoteca de cuadros artísticos y coloniales del convento de San Agustín, precedidas de las biografías del P. Basilio de Ribera y Miguel de Santiago.* Quito: Bona Spes.

Terán Najas, Rosemarie. 1994. *Arte, espacio y religiosidad en el convento de Santo Domingo.* Serie: Estudios y Metodologías de Preservación del Patrimonio Cultural 4. Quito: Proyecto Ecuador-Bélgica.

Vargas, Fr. José María. 1944. *Arte quiteño colonial.* Quito: Litografía e Imprenta Romero.

———. 1957. *Miguel de Santiago y su pintura.* Discurso de incorporación como miembro de número en la Academia Nacional de Historia y contestación de J. Roberto Páez (Inaugural lecture to the National Academy of History, with reply by J. Roberto Paez). Quito: Ed. Santo Domingo.

———. 1964. *El arte ecuatoriano.* Quito: Ed. Santo Domingo.

———. 1967. *El arte religioso en Cuenca.* Quito: Ed. Santo Domingo.

———. 1971. *Los pintores quiteños del siglo XIX.* Quito: Ed. Santo Domingo.

———. 1981. *Miguel de Santiago y su Doctrina Cristiana.* Quito: Ed. Royal.

Vives Mejía, Gustavo. 1998. *Presencia del arte quiteño en Antioquia, pintura y escultura, siglos XVIII y XIX*. Medellín: Universidad EAFIT–Fondo Editorial.

Webster, Susan V. 2002. "La presencia indígena en las celebraciones y días festivos." In *Arte de la Real Audiencia de Quito, siglos XVII-XIX. Patronos, corporaciones y comunidades*, ed. Alexandra Kennedy, 129-143. Hondarribia: Editorial Nerea.

Photograph & Object Credits

Samuel Edgerton Essay
Figures 1-4 Drawings by Mark Van Stone.
Figure 5 From Miguel Angel Fernández, *La Jerusalen Indiana: Los conventos-fortaleza mexicanos del siglo XVI,* Mexico City, 1992, p. 195. Photo by Bob Schalkwijk.
Figure 6 From Miguel Angel Fernández, *La Jerusalen Indiana: Los conventos-fortaleza mexicanos del siglo XVI*, Mexico City, 1992, p. 38. Photo by Bob Schalkwijk.
Figure 7 By permission of the British Library.
Figure 8 Photo by Jeff Wells.
Figure 9 Photo by Jorge Pérez de Lara.
Figures 10-12 Photos by Jeff Wells.
Figure 13 Courtesy of the Museum of Fine Arts, Boston, Ernest Wadsworth Longfellow Fund.
Figures 14-16 Photos by Jeff Wells.
Figures 17-18 Photos by Jorge Pérez de Lara.
Figure 19 From Justin Kerr, *The Maya Vase Book: A Corpus of Rollout Photographs of Maya Vases*, New York, 2000, Vol. 6, p. 949. Rollout Photograph (c) Justin Kerr File no. K5975
Figure 20 Photo courtesy Vatican Museum.
Figure 21 Photo by Jeff Wells.

Jeanette Favrot Peterson Essay
Figure 5 Photo courtesy Manuel Serrano Cabrera.
Figure 6-7 The Metropolitan Museum of Art, Gift of H.H. Behrens, 1948 (48.70)
Figure 8 Courtesy Convento de las Concepcionistas, Agreda, Spain. Photo by Alejandro Plaza.
Figure 9 Denver Art Museum, Collection of Jan and Frederick R. Mayer (191.1996).
Figure 10-11 Denver Art Museum, Gift of Mr. and Mrs. George C. Anderman and an anonymous donor (1976.56).
Figure 12 Consejo Nacional para la Cultura y las Artes (CONACULTA) – Instituto Nacional de Antropología e Historia (INAH) - Collection of Museo Nacional del Virreinato
Figure 13 Consejo Nacional para la Cultura y las Artes (CONACULTA) – Instituto Nacional de Bellas Artes (INBA) - Collection of Museo Nacional de Arte
Figure 16 From *Imagenes Guadalupanas Cuatro Siglos*, Cat. 119, p. 207

Carolyn Dean Essay
Figure 1 Denver Art Museum, Gift of Dr. Belinda Straight (1977.45.1-.16).
Figure 6 Denver Art Museum, Gift of Dr. Belinda Straight (1996.18). Photo by Eric Stephenson.

Juana Gutiérrez Haces Essay
Figures 1-4 Photos by Rafael Doniz.
Figure 5 Photo by José Ignacio González Manterola, Pablo Oseguera.
Figures 6-10 Photos by Rafael Doniz.
Figure 12 & 14 Photo by Rafael Doniz.
Figure 15 Denver Art Museum, Collection of Jan and Frederick R. Mayer (TL-24505). Photo by Jeff Wells.
Figures 16 Photos by Rafael Doniz.
Figures 17-18 Photos by Carlos Alcázar.
Figure 19 Photo by Arturo González de Alba.
Figure 23 Photo by Rafael Doniz.

Alexandra Kennedy-Troya Essay
Figure 1 Photo by Alfonso Ortiz.
Figure 2 Denver Art Museum, Gift of Mr. and Mrs. John Pogzeba (1974.265).
Figures 3-4 Photos by Alfonso Ortiz.
Figure 5 From José Gabriel Navarro, *La pintura en el Ecuador del XVI al XIX*, Quito: Dinediciones, 1998, p. 89.
Figure 6-7 Photos by Alfonso Ortiz.
Figure 8 Photo by Alexandra Kennedy.
Figure 10-11 Photos by Alexandra Kennedy.